JOHN MARTIN

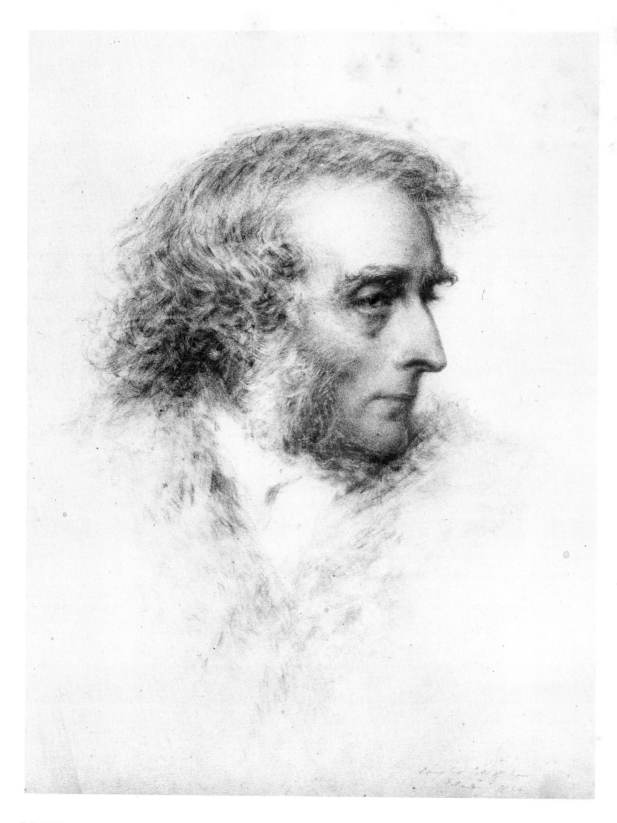

PORTRAIT OF JOHN MARTIN 1854 by Charles Martin
Chalk. 60.3 x 48.2
Inscribed 'Douglas, Isle of Man, February 1854'
Laing Art Gallery

JOHN MARTIN

CHRISTOPHER JOHNSTONE

ACADEMY EDITIONS · LONDON

ST. MARTIN'S PRESS · NEW YORK

First published in Great Britain in 1974 by
Academy Editions 7 Holland Street London W8

Copyright © Academy Editions 1974 All rights reserved

SBN cloth 85670 175 0 SBN paper 85670 180 7

First published in the U.S.A. in 1974 by
St. Martin's Press Inc. 175 Fifth Avenue New York N.Y. 10010

Library of Congress Catalog Card Number 73 - 93029

Printed and bound in Great Britain at
Burgess & Son (Abingdon) Ltd.

CONTENTS

ACKNOWLEDGEMENTS

My special thanks are due to the owner of *The Plains of Heaven* whose admiration for Martin and assistance in obtaining indispensible photographs and information provided the initial impetus for the book.

The Eve of the Deluge is reproduced with the gracious permission of Her Majesty the Queen.

I am no less indebted to the other private collectors, museums and galleries, and scholars who freely gave help by supplying photographs, information or advice, in particular: Mr. Richard Green of the Laing Art Gallery, Mrs. Ruth Wright, Mr. Charles Jerdein, Mr. William Feaver and the Tate Gallery.

THE PLATES

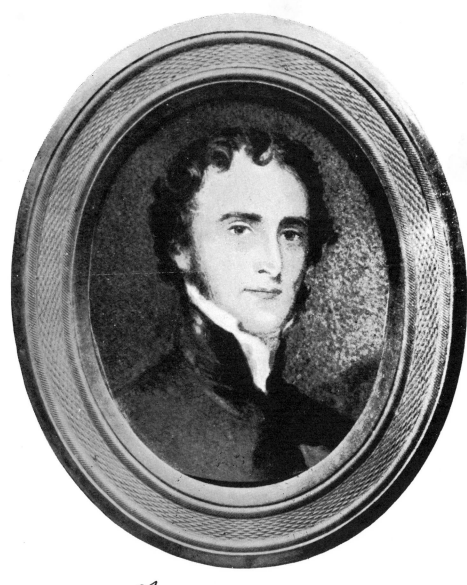

PORTRAIT OF JOHN MARTIN
after a miniature by Charles Muss

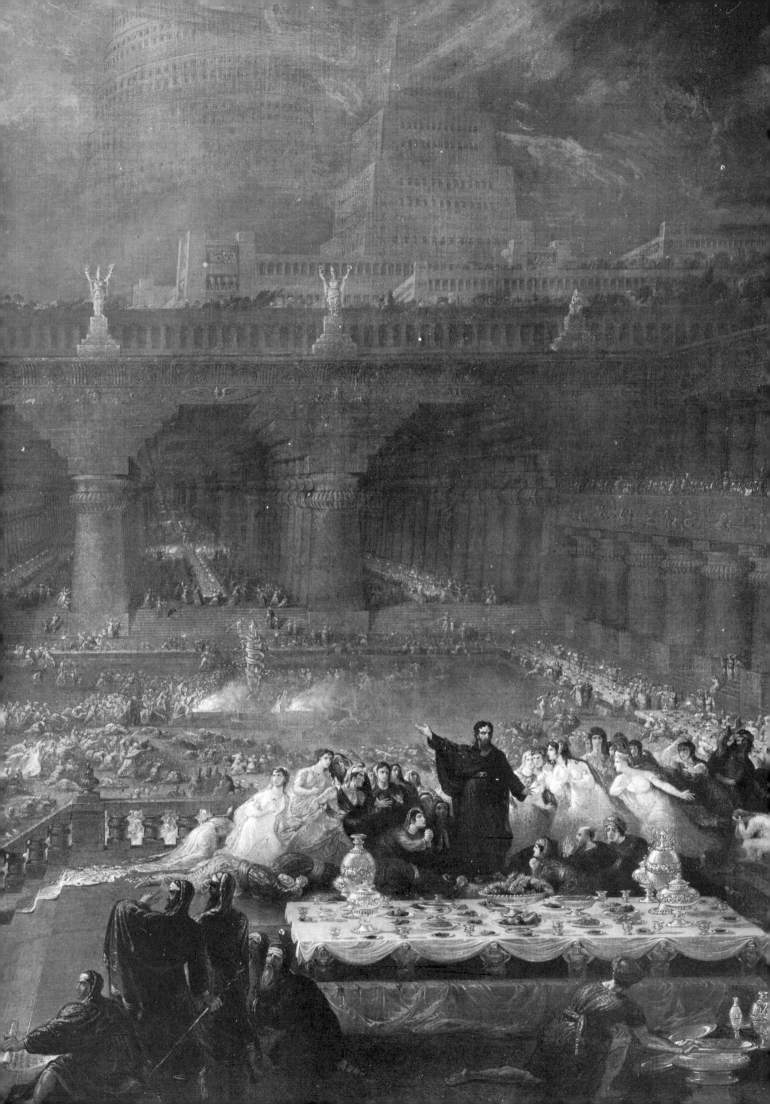

JOHN MARTIN, as a young lad of 17, arrived in London in 1806 in search of work which would eventually enable him to follow his chosen career as a painter.

The year was an important one in many ways, both for Martin and for British painting. It was the year that the British Institution opened as an alternative exhibition space to the Royal Academy, taking over the Boydell's Shakespeare Gallery which had collapsed due to the death of the owner and financial troubles. It was the year of James Barry's death, the last of the great history painters of the 18th century; yet another, not so great, was re-elected President of the Royal Academy - Benjamin West. Fuseli had been appointed Keeper of the Royal Academy in 1804. And it was the year that Turner exhibited the painting which greatly reveals the influence he was to have upon Martin - *The Goddess of Discord choosing the Apple of Contention in the Garden of the Hesperides.*

The years of Martin's life leading up to 1811, when he exhibited his first painting at the Academy, are not documented in detail. But during those five years, working on and off during the daylight hours and painting by candle-light early into the morning, a young and talented artist with Martin's enthusiasm and desire for success must have been aware of the artistic climate of the first decade of the century, what led up to it, and in what direction his own future was to lie. The painting of historical events was still the only way to highest academic honours, and the only choice for Martin who was only once a portrait painter. He would certainly have been aware of the subjects which had been exhibited during the height of the English neo-classical era, and that hazy period when the neo-classical became the romantic - one genre of which, the sublime, would only die with him in 1854 - for Millais and Rossetti had already ushered in the new era of romanticism.

The 'sublime' was Martin's painted world. But this was not the necromantic 'Gothik Horror' of Mortimer's *Sextus* of thirty years earlier complete with the witch Erictho, mangled corpses, writhing snakes and horrid prophecy; neither of the modern Copley's *Watson and the Shark,* nor of Fuseli's morbid and erotic dreams.

Martin knew their work and learnt from it, and from the work of their literary contemporaries: Walpole's *Castle of Otranto* (1764), Beckford's *Vathek* (1782), Lewis's *The Monk* (1796) and later Mary Shelley's *Frankenstein* and Maturin's *Melmoth the Wanderer.* But it was not their subjects which are reflected in Martin's paintings, but their conceptions of atmosphere and vastness, tragedy and death - in short, their 'sublimity'.

Mrs. Radcliffe's *The Mysteries of Udolpho* and Beckford's *Vathek* no doubt come closest as precedents for Martin's visions in their descriptive passages; as for example the following from *Vathek:*

'The Caliph and Nouronihar beheld each other with amazement . . . But their eyes at length growing familiar to the grandeur of the surrounding objects, they extended their view to those at a distance and discovered rows of columns and arcades . . . The pavement strewed over with gold dust and saffron, exhaled so subtile an odour as almost overpowered them . . . They however went on, and observed an infinity of censers, in which ambergrise and the wood of aloes, were continually burning . . .'

Martin was evidently sympathetic to Beckford's vision. He became friends with Beckford, as de Loutherbourg had been earlier, and provided the designs for the engravings of Fonthill Abbey by which it is now known in John Rutter's *Delineations of Fonthill and the Abbey* (1823) and Britton's *Graphical and Literary Illustrations of Fonthill . . .* published in the same year, together with his first designs for other engravers.

One of the first English precedents for Martin's conception of the powers of sublime subject is to be found in 1712, in Joseph Addison's *Essay on the Pleasures of the Imagination* in *The Spectator,* a century before Martin's first exhibited subject picture. Addison wrote with special reference to Milton's descriptions of grandeur and sublimity 'striking the Imagination with something astonishingly great and wild', 'greatness' being 'not only the bulk of any single Object, but the Largeness of a whole View, considered as one entire Piece. Such are the Prospects of an open Champian country, a vast uncultivated Desert, huge Heaps of Mountains, high Rocks and Precipices, or a wide Expanse of Waters, where we are not struck with the novelty or Beauty of the sight, but with that rude kind of Magnificence which appears in many of these Works of Nature.'

Addison also prophecied the chief criticism aimed at Martin, other than that intimated above, where the rules of history painting are broken by emphasizing the landscape rather than the heroes and protagonists. He goes on to discuss the poet's (and equally the painter's) ability to 'humour the Imagination in its own Notions' so that it can 'fancy to itself Things more Great, Strange, or Beautiful, than the Eye

11

ever saw by mending and perfecting Nature where he described Reality, and adding greater Beauties than are put together in nature where he describes Fiction' as long as in doing this he does not transform nature too much, and 'run into Absurdities by endeavouring to excell.'

Edmund Burke was to take up Addison's *Essay* as the basis of his *A Philosophical enquiry into the origins of our ideas of the Sublime and the Beautiful*, 1757, but whether Martin had read these early aestheticians is not known. His paintings and what he wrote about them are the only evidence we have: for example his descriptive catalogue to *The Fall of Ninevah*: 'The mighty cities of Ninevah and Babylon have passed away. The accounts of their greatness and splendour may have been exaggerated. But, where strict truth is not essential, the mind is content to find delight in the contemplation of the grand and the marvellous. Into the solemn visions of antiquity we look without demanding the clear daylight of truth. Seen through the mist of ages the *great* becomes *gigantic,* the *wonderful* swells into the *sublime.'*

The landscape which greatly influenced Martin was that of his youth, those sixteen years spent in Northumberland before coming to London. He was born in East Landends, Haydon Bridge, on July 19th, 1789, the youngest of thirteen children only five of whom survived born to Fenwick and Isabella Martin. The parents would appear to have contributed as much to the character of John and his art as the park-like scenery of the South Tyne Valley and the wilder reaches of the River Allen, the gorge and surrounding moorland.

Fenwick Martin was a roving jack-of-all-trades, never settling down, even after his Gretna Green marriage to Isabella Ridley. He was at different times a tanner, a fencing and single-stick instructor ('the best swordsman in the Kingdom, and not afraid of any man as a fencer or pugilist' according to William Martin), a soldier during the American Revolution, a peddlar and a publican.

On the other hand, Isabella, probably descended from the Protestant Martyr Bishop Nicholas Ridley, was of a more stable upbringing, coming from a relatively well-off family, accustomed to two prayer-meetings daily, and for whom the Old Testament provided all the rules necessary for daily conduct. Her influence, epitomized by the dictum 'that there was a God to serve and a hell to shun, and that all liars and swearers are burnt in Hell with the devil and his angels' and the thorough knowledge of the Bible, was to be an abiding source for not only Martin's paintings, but also the religiously-oriented careers of the other children.

William, the eldest, was a self-declared 'Natural Philosopher' of the anti-Newtonian breed, who published over two hundred pamphlets on religious themes and his inventions. Richard, who spent most of his life in the army and was present at the Battle of Waterloo, rose to the rank of quarter-master sergeant in the Grenadier Guards. He also published some minor poetry in 1830, and is credited with further pamphlets on Perpetual Motion, though this is very likely due to confusion with William. Jonathan achieved a more permanent notoriety as incendiarist of York Minster in 1829. He spent most of his life in asylums, and it is due to confusion with him that John acquired the nickname 'Mad Martin', and that Blake was thought to have spent some time in Bedlam.

John attended the Haydon Bridge Grammar school, where he would have been taught grammar, writing, mathematics and navigation, and Latin and Greek, if his parents could have afforded the penny per quarter extra charge for instruction. Martin was never to credit this early schooling with much importance, though the seeds of his later erudition must have been planted there. Certainly his love for drawing and sketching were first brought out while at school, as there are stories of him making caricatures on walls with a burnt stick, or in the wet sand by the river, and copying 'the engraved alphabet with accuracy, though he knew only a few of the characters'. He himself relates that he discovered in the abandoned Langley Castle an old canvas upon which he overpainted his grandmother's car with house paint and home-made colours. One of the few ways in which a young man could start on the road towards being an artist was to be apprenticed to a herald painter, and like Crome a decade or so earlier Martin was to get his first training in this trade. His family moved to Newcastle in 1803 and John spent a year with Leonard Wilson, a coach-builder. At the end of the year Wilson tried to avoid paying the wage increment which was due. Martin took the case to court, winning it with the aid of Wilson's own witness who substantiated Martin's statement of the facts, and had his indentures returned. Speaking his own mind was definitely a trait inherited from his father and one which would be a salient characteristic in his later life, especially when faced with dishonesty.

Martin was now free to devote his time seriously to his art. His family fully supported his decision and admired his spirit. In his own words, he 'roamed the hills at day-break, exulting in the sublime grandeur

of the surrounding beauties of Nature, watching the effects of light and shade and trying to imprint those beautiful images indelibly upon my memory which, upon my return home, I endeavoured to re-trace on paper.'

However, his desire to remedy his lack of knowledge led him to persuade Fenwick to find a master for him. Boniface Musso was the drawing master who took Martin as a student, and who gave him his first opportunity to take positive steps towards a successful career not only through his teaching, but also through encouragement and kindness. Musso, a Piedmontese settled fourteen years in Newcastle, gave him lessons twice a week for a quarter. When the following quarter Fenwick could no longer pay, Musso, knowing that Martin's talent was worth fostering, continued his instruction free, even allowing him to be present on Sundays, the only day he painted in oils, while Martin's parents believed their son to be in church! He was also able to study Musso's collection of engravings after Claude and Salvator Rosa, which influenced his later work.

Musso's son, Charles Muss, who later became a celebrated enamel painter, had left for London a little before 1806 to work in a china painting business. He invited Musso to join him as there was work available, and Musso in turn suggested that Martin should accompany him. Despite his youth and the fact that Musso was a Roman Catholic, Martin persuaded his parents to allow him to go, assuring them that he would not be pressed into the navy, as Jonathan had been two years earlier.

Martin took a Newcastle trader to London in September. But when he arrived, his loose cash stolen en route, a worse fate greeted him, since he had crossed with a letter announcing that both Muss and Musso were out of work. Undaunted, the young man managed to turn his misfortune to good use, and benefited from the situation by making sketches from memory of the Northumberland landscape and scenes like Langley Castle, and hawking them around the dealers. One of these was Ackermann who was later to publish his first work, having forgotten their earlier meeting when he beat down the price Martin was asking for some drawings.

Martin managed to earn about 10 shillings a week from his drawings and continued to stay and study with the Musses. Eventually, Charles started his own glass and china business where Martin was paid £2 a week, of which £1 went towards his instruction in designing and decorating ware.

When the enterprise went bankrupt in 1809, Charles joined William Collins's famous glass company. Martin followed him under the same agreement, and shortly afterwards married a friend of the Musses, Susan Garret, and settled with her in lodgings behind Collins's shop in the Strand.

During this period he studied painting assiduously, 'sitting up at night till two or three o'clock, even in winter, acquiring that knowledge of perspective and architecture which has since been so valuable to me,' as he told *The European Magazine* in 1822. Certainly his 'self-improvement' was such that he no longer paid Muss for instruction, but took pupils himself, and in 1810 was to have an oil painting rejected by the Royal Academy. However, he was successful the following year for *Landscape Composition* was accepted. His skill in glass-painting did not go unnoticed, for his work was selling better than that of his fellow workers, who became jealous and spiteful. Their treatment of him, coupled with their 'discordant' tastes, habits and views, compelled Martin to give up his job with Collins in 1811 or 1812, and move to Marylebone High Street with his wife and two children, where he was to commence his career as a painter of pictures, no longer on glass and china, but on canvas.

But he did not entirely break with the ceramic trade and the Musses, for when Charles Muss died in 1824, having held the position of Enamel Painter to King George IV for several years, Martin undertook to finish his many commissions for his widow - no easy task, considering the size of the works Charles was engaged upon at the time, especially large copies of Old Masters. And in 1835, ten years later, he gave evidence before a Select Committee on the Arts, the report of which states: 'The want of instruction experienced by our workmen in the Arts is strongly adverted to by many witnesses . . .Mr. Martin (the celebrated painter) complains of the want of correct design in the China trade . . .'

Martin's first exhibited subject-painting was *Sadak in Search of the Waters of Oblivion*. Though hung in the Ante-room at the Royal Academy in 1812, it was mentioned in reviews, which must have been encouraging for a young man of 23. Martin's choice of subject is reflected throughout his later work. He illustrated an exotic and romantic tale involving man, nature and morality, in which he could emphasize the vast forbidding landscape bathed in an ominous red light, and allowed the full use of chiaroscuro which was always a characteristic of his later pictures.

Although returned after the exhibition, *Sadak* was later bought by William Manning, a Member of

Parliament and Governor of the Bank of England. It was an important sale for Martin because since he reduced the price to 50 guineas, Manning generously put himself in the artist's debt and in 1818, despite Martin's aversion to borrowing money, lent him £200 to enable him to buy his first house on the New Road, now the Marylebone Road.

The five years that led up to his move to what eventually became Allsop Terrace were quite eventful for the struggling artist. In 1813 his mother and father and son Fenwick all died, but his daughter Isabella was joined by a second son, John. By 1818 there were four children: Isabella, Alfred, Zenobia and Leopold Charles, John having died in 1814. Charles and Jessie were his last children born in 1830 and 1825 respectively.

Leopold was christened after his godfather, Prince Leopold of Saxe-Coburg, who had stayed for two months in the same house as Martin on Marylebone High Street in 1814, having come to England in the entourage of the King of Prussia. He and the painter became good friends, and when Prince Leopold returned to England two years later as the son-in-law of the Prince Regent he appointed Martin Historical Landscape Painter to himself and Princess Charlotte, a post influenced no doubt by the success of *Joshua Commanding the Sun to Stand Still* exhibited at the Royal Academy that same year.

At this time he was still teaching (Princess Charlotte was one of his pupils) and painting and exhibiting small pictures, such as the *Distant View of London* and *View of the Entrance to Carisbrooke Castle*. He was also painting water-colours and doing glass enamel painting.

More important to his career, however, he was also becoming increasingly proficient in print-making. His first etchings date from 1816, and the following year Ackermann published his first commission *Characters of Trees*. During the next two years he must have made the etchings for Sezincot House which were probably printed in 1819, the drawings for which were exhibited at the Academy in 1818. The move to Allsop Terrace did not allow him much time to paint a large picture to follow the unsuccessful *Bard* of 1817, but in 1819 he was again ready to surprise the public with his growing talents.

The Fall of Babylon. exhibited at the British Institute, was greeted with public and critical acclaim, as witnessed by *The Examiner*: 'The spectators crowd round it some with silence, some with exclamatory admiration; sometimes very near to look at the numerous small objects that cannot be distinguished at a distance, sometimes further off to feast upon the grandeur of the whole; leaving it, but still thrilling with the strange and felicitous expression, coming back to look at it again, after having looked at most of the other pictures with an absent mind, like a lover who is but half attentive to other women in delicious reverie on the superior charms of her who has the keeping of his heart. So exuberant is this noble work in matter for gazing and description that a very extended criticism ought to be written upon it to do it justice.'

The painting was immediately bought by the collector Henry Hope at Martin's price of 400 guineas, enabling him to pay back Manning's loan with interest and putting his finances on their most secure footing yet. The criticism aimed at *Joshua* in 1816, that it broke all the rules of 'history painting' due to the subordination of the hero to architecture and landscape, did not detract from its brilliance, and it was awarded the second premium of £100 when re-exhibited at the Institution in 1817. But no criticism was voiced over *Babylon*. It was a *tour de force*, the originality of which would only be surpassed by Martin's later paintings.

The great novelty of *The Fall of Babylon* lay in Martin's conception of the architectural setting. *Joshua* was his first painting to introduce architecture, and the city of Gideon is quite grandiose, though tucked away in a corner. But in *Babylon* the landscape has been radically reduced to a tiny vista beyond the city. Martin's contemporaries, and indeed scholars well into this century, believed that the artist's imagination was the sole source for the appearance and obsessive piling up of edifice upon edifice (as in the mountains in both *Sadak* and *The Bard*). And yet Martin was concerned down to the minutest detail with the accuracy of his architectural and historical 'reconstruction', first made apparent in the pamphlet describing *Belshazzar's Feast,* probably published in 1821.

Though this is the first published instance of Martin's obsessive cataloguing of details and dimensions of objects depicted in the paintings, he had several years earlier taken the trouble to indicate the heights of the trees in his drawings for *Characters of Trees*; and, in a sketch book in the Ashmolean, dating from 1817-1818, he appended the following note to an architectural study: 'There were stones in the walls of Jerusalem 20 cubits long, 10 cubits broad, and 5 cubits in depth. Cubit 1ft. 5 inches.'

There can be little doubt, therefore, that along with all his painting and teaching, Martin had been study-

ing the most up-to-date information on the ancient Near East and India. Drawings by the Daniells had surely been available to him when working at Sezincot House, as well as the published works by the artists: *Views in India* (1792), *Oriental Scenery* (1792-7), *Antiquities of India* (1799), and *Hindoo Excavations in the Mountains of Ellora* (1803). And although he apparently did not own them (since they do not appear in his library sold at Lindsey House after his death), he must have had access through his friends to many of the other archaeological works published at the turn of the century.

There were no illustrations of Babylon and Ninevah from which he could work, so Martin carefully worked from prose descriptions from the Bible and historians, together with contemporary accounts of the remains of the various sites. Examples of the former are the writings of the theologian and Biblical scholar, the Reverend Thomas Maurice: *History of Hindostan* (1795-98) and *Observations on the Ruins of Babylon* (1816), a commentary on C. J. Rich's *Memoirs of the Ruins of Babylon* published the previous year.

Of more archaeological importance was the *Description de l'Egypte,* published between 1809 and 1829, compiled by the artists and scholars who accompanied Napoleon in the Egyptian campaign of 1798, the year which saw the publication of Louis Cassas' *Voyage Pittoresque de la Syrie, de la Phoenicie, de la Palestine, et de la Basee-Egypte.* Only two years before the exhibition of *Belshazzar's Feast,* Belzoni had published an account of his own findings, *Narrative of the Operations and Recent Discoveries with the Pyramids, Tombs and Excavations in Egypt and Nubia.*

Comparisons between the illustrations in the various books and Martin's major Biblical paintings and engravings show that he had consulted the best sources available for his architectural details, aided by accounts by Herodotus, Strabo, Diodorus Siculus and other historians, who are cited in his descriptive pamphlets. In particular he was careful to select details of arches, columns and entablature, and ziggurats, the latter being peculiar to Babylonian architecture, though equivalents can be found in other cultures. The Temple of Jupiter Belus, which appears in the middle of the *Babylon,* and the Hanging Gardens, have been considered more convincing than modern archaeological reconstructions.

However, although Martin lifted designs straight out of most of the published works, there was plenty of scope for his imagination. He gives only a shadowy glimpse of the Tower of Babel, of which there are no contemporary descriptions, in *Belshazzar's Feast.* Since 'it was the custom of Nebuchadnezzar, the conqueror of Egypt and India, to bring from these parts to Babylon, all the architects, the men of science and handicrafts, by whom the Palace and the external parts of the Temple of Bel, etc., were built', Martin supposed that 'the united talents of the Indian, the Egyptian and the Babylonian architects were employed to produce those buildings'. Hence there are Indian columns with Egyptian pediments, and in the *Ninevah* 'the style of architecture, partaking of the Egyptian on the one hand, and of the most ancient Indian on the other, has been invented as the most appropriate for a city situated between the two countries, and necessarily in frequent intercourse with them'

In 1820, the year between the exhibition of *Babylon* and that of *Belshazzar's Feast,* Martin understandably did not produce much work. However one large painting *Macbeth* was exhibited at the British Institute. Martin called it one of his most successful landscapes, but though re-exhibited in 1822 at the first exhibition of the Northumbrian Institute, it remained in his studio unsold for at least ten years. At the Academy two sepia drawings were exhibited of a proposed monument to commemorate the Battle of Waterloo, the first public evidence of Martin's growing interest in engineering and London planning. The same year Martin was proposed as an Associate of the Academy. He received not one vote, and did not appear to be much bothered, although he must have accepted his name being proposed. He showed some antagonism towards the Academy all his life, dating from the exhibition of *Clytie,* which was destroyed by a careless Associate of the Royal Academy or Royal Academician spilling varnish down the middle of it. Although West, the President of the Royal Academy, sent his son with apologies, the memory of the occasion emphasized for him the absurdity of the rules of the body, and he was one of the several artists, with Haydon, who testified against it before a Select Committee in 1836.

In 1821 *Belshazzar's Feast* was hung on the line at the British Institute, and awarded the 200 guineas first premium. The subject had been suggested to him by the American painter Washington Allston, whom Martin had met through C. R. Leslie, around whom formed a small American artistic community in London. Leslie attempted to deter Martin from attempting to paint his grandiose scheme, partly because he admired Martin's talent and thought his career would be ruined if the painting was unsuccessful, and partly, no doubt, because Allston had almost finished his own version. Martin was far too strong-

willed to accept Leslie's advice. 'I mean to paint it', he replied to Leslie, 'and the picture shall make more noise than any picture ever did before. Only don't tell anyone I said so.' Nevertheless, Martin's fame was such that he was constantly visited in his studio by the most famous personalities of the day in both the artistic and the literary world. The news soon got round that Martin was working on an architectural *tour de force*. Two of the visitors were Mrs. Siddons and Charles Young, who suggested the pose for the prophet Daniel.

Possibly as a result of the diverse opinions held by many of the people who wrote to him about his representation of the Biblical story, Martin decided to make his conception of it quite clear and had a four-page quarto prospectus printed. This was the first of at least eleven such pamphlets which he published to accompany his historical paintings. The format was basically the same for all, containing an outline engraving upon which all the principal objects were numbered; these were then listed, followed by a text quoting the historical sources, passages from the Bible and occasionally poetry either based on the story or eulogising the painting itself.

Opinion on *Belshazzar's Feast* was certainly divided, but the public flocked to see it. William Collins, who had once employed Martin at 2 guineas a week, immediately purchased it for an undisclosed price, and when the exhibition closed following a three week extension, Collins re-exhibited in the Strand. Among the favourable opinions expressed was that of the painter Wilkie, greatly admired by both Martin and Turner: 'The British Gallery has been some time opened' he wrote to Sir George Beaumont. 'There are a number of pieces in a small way good. Ward, Etty, Stark, Crome and Landseer are successful, though in no great work. But Martin is certainly the first, both in effort and in success. His picture is a phenomenon. All he has been attempting in his former pictures is here, brought to its maturity; and although weak in all those points in which he can be compared with other artists, he is eminently strong in what no other artist has attempted. *Belshazzar's Feast* is the subject; and in treating it, his great elements seem to be the geometrical properties of space, magnitude and number, in the use of which he may be said to be boundless. The great merit of the picture, however, is perhaps the contrivance and disposition of the architecture, which is full of imagination.'

Charles Lamb was later to write on Martin and *Belshazzar* at some length in his *Essays on the Barrenness of the Imaginative Faculties in the Production of Modern Art* (1833): 'His towered structures are of the highest order of the material sublime. Whether they were dreams, or transcripts of some elder workmanship, Assyrian ruins old, restored by this mighty artist, they satisfy our most stretched and craving conceptions of the glories of the antique world. It is a pity that they were ever peopled. On that side the imagination of the artist halts, and appears defective . . .'

It was probably Martin himself who wrote the erudite dissertation on *Belshazzar's Feast* which Collins had printed and sold at 343, Strand, while the paintings were on display. The form he used was that of a Greek tragedy, divided into the three sections, protasis, epitasis and catastrophe. Item 17 in the references to the etching is characteristic: 'Scale of proportion, a figure six feet high, by which the length of the halls is found to be one mile.'

Following the success of *Belshazzar*, Martin was soon at work on his next large painting *The Destruction of Pompeii and Herculaneum,* commissioned by the Duke of Buckingham who had failed to buy *Belshazzar.* Instead of sending it to the Institute, he decided to make it the main attraction in a one man show at the Egyptian Hall (or Bullock's Museum) in Piccadilly in 1822, for which he managed to borrow all his major paintings to date, but not *Belshazzar's Feast.* Although the exhibition was successful, as far as attendance went, *The Destruction of Pompeii and Herculaneum* was not highly thought of. Furthermore, there is no evidence that there was a measured increase in commissions or personal distinction, publicity being the implicit aim of the undertaking.

In 1823 a large painting *Adam and Eve entertaining the Angel Raphael* was at the Institute and *The Paphian Bower* at the Academy. By 1834 Nash's new Galleries for the Society of British Artists were finished and Martin's *Seventh Plague of Egypt* was the main attraction in the first exhibition. Although he was to be a subscriber to the Society for several more years, having been one of the founding artists, Martin did not become a member because of the restriction against exhibiting at The Royal Academy, even though he did not send another painting there until the re-exhibition of *The Deluge* in 1837. Furthermore, having found fault with the Academy and The British Institution, it is not surprising that he was suspicious of yet another similar organisation. Although a landscape and design for the *Seventh Plague* were at the Academy

and a large painting of *Syrinx* at the Institute in that same year, Martin was by this time hard at work on the mezzotint illustrations for Milton's *Paradise Lost,* commissioned by Prowett, having put aside the plate of *Belshazzar's Feast* which would have been his first large historical mezzotint and was finally published in 1826. One of Martin's first contacts with *Paradise Lost* is quite likely to have been when he was staying with the Musses. Among their circle of friends were Schiavonetti and Bartolozzi the engravers. Bartolozzi had engraved most of Stothard's designs illustrating Milton's poems published by Jeffreys' in 1792-3 (and later augmented by new plates in the 1818 and 1826 editions). There were of course many other illustrated editions of Milton's poetry available to him, as well as independent engravings and paintings from throughout the 18th century. It is probably Fuseli and Westall who relate most closely to Martin, though it would be difficult to determine direct influences and iconographic borrowings from either. No artist before Martin had really attempted to give an impression of the vastness of Eden, though Richter (1794) and Burney (1796) tried to portray a luxuriant fertile parkland in the small vistas beyond the figures. Similarly, the appearance of Hell had never been given any importance. There are occasional glimpses of a classical edifice representing Pandemonium, mostly obscured by the dark undefined backgrounds of the other views of Hell. Martin's figures, though not very adept, tend to respond to the mood of the illustration, in contrast to those of Fuseli, for example, which convey the dramatic content alone. Martin's are undoubtedly among the most original illustrations to *Paradise Lost* (along with those by Blake), and there is hardly another artist whose graphic style is so suited to depicting the emotions embodied in Milton's descriptions, so much admired by Addison and Burke.

Twenty of the mezzotints were exhibited at the British Artists in 1824, along with one large painting of the *Creation of Light.* Contemporary critics found fault with both. The design of the latter was similar to that of the *Paradise Lost* mezzotint and *The European Magazine* called it absurd beyond all conception in a damning review of the British Artists as a whole, although finding Haydon and Martin 'the only clever men in the Suffolk Street Academy.' B. R. Haydon himself, at times both friend and ally to Martin, criticised the painting at great length in his diary. According to him it was 'a total failure from his ignorance of the associations and habits of the mind. No being in a human shape has ever exceeded eight feet. Therefore to put a human being with a hand extended and a large circular flat body not much larger than the thing shaped like a human hand and four fingers, and call that body the sun, makes one laugh; for no effort can get over the idea that it is not larger than a hand There is nothing grand in a man stepping from York to Lancaster; but when he makes a great Creator fifteen inches, paints a sun the size of a bank token, draws a line for the sea and makes one leg of God in it and the other above, and says: "There! That horizon is twenty miles long and therefore God's leg must be sixteen relatively to the horizon", the artist really deserves as much pity as the poorest maniac in Bedlam.'

Although Haydon has amusingly captured one aspect of the essence of Martin's working premises, for architectural subjects, the conception of the mezzotint is unquestionably brilliant and influenced Doré when he came to illustrate the same subject. Furthermore, Martin repeated the idea in his large plate of *The Destroying Angel* of 1836, whose quality is unsurpassed by the most exotic of the illustrators of the '30s of this century.

By 1826 *Paradise Lost* engravings were finished, though the final part was not issued until 1827, and Martin's next major painting *The Deluge* was exhibited at the British Institute. Recently new light has been shed on the intriguing relationship between Danby and Martin in regard to *The Deluge.* That Martin had plagiarised Danby's idea for *The Sixth Seal,* not exhibited until 1828, has been stated quite vehemently in two letters written in 1826, the most explicit of which was written by Thomas Beddoes to B. W. Proctor: 'Have you seen Martin's *Deluge*? Do you like it? And do you know that it is a rascally plagiarism upon Danby? Danby was to have painted a picture for the King: subject *The Opening of the Sixth Seal* in the Revelations: price 800 guineas. He has collected his ideas and scene, and very imprudently mentioned them publicly to his friends and foes it appears. And lo! his own ideas shone at him out of Martin's canvas at the Institute'.

However, although the compositions are similar, though reversed, there was no concrete evidence to support the allegation. Furthermore, other rumours abounded, that for instance Danby had moved from Bristol to London to oppose Martin on the instigation of the Academicians. Yet, a letter from Danby to John Gibbons, a Bristol ironmaster and his early patron, relates the whole story. It transpires that not only were Martin and Danby friends, they had made an agreement not to look at each other's paintings

until they were finished. Thus at Martin's house one evening Danby quite openly described the studies he had been making for some years for a painting of *The Deluge* and related all the incidents in what he had decided would be his next painting, *The Sixth Seal*. Later, when it was learnt that Martin was working on his *Deluge*, Danby had the wind completely taken out of his sails: he discovered that Martin had gained access to his painting room while he was out, and had stolen both the subject and the composition and details, from both Danby's paintings.

One aspect of Martin's *Deluge* was of particular interest and reflects his study of the natural sciences, for in 1834, the French naturalist Baron Cuvier visited Martin to see the painting (or a version of it) 'on account of my [Martin's] having . . . made the event the consequence of sun, moon and comet in conjunction; the moon and comet drawing the water over the earth. This was Cuvier's opinion, he told me so, and he expressed himself highly pleased that I had entertained the same notion.'

In the same year Martin also made the acquaintance of Dr. Gideon Mantell, author of *Wonders of Geology* (1838), who recorded the visit in his journal: 'Among the host of visitors who have besieged my house today was Mr. John Martin (and his daughter), the celebrated, most justly celebrated artist whose wonderful conceptions are the finest productions of modern art. Mr. Martin was deeply interested in the remains of the Iguanodon, etc. I wish I could induce him to portray the country of the Iguanodon. No other pencil but his should attempt such a subject.' Martin was persuaded, and a mezzotint of the painting appeared in Mantell's book four years later. According to Mantell, the country of the Iguanodon was one 'which language can but feebly portray, but which the magic pencil of a Martin, by the aid of geological research, has rescued from the oblivion of countless ages, and placed before us in all the hues of nature, with its appalling dragon-forms, its forests of palm and tree-ferns, and all the luxuriant vegetation of a tropical clime.' A reconstruction of a different kind was undertaken probably at the instigation of John Britton. It is a large unsigned and undated sepia and ink drawing, now in the Wiltshire Museum, of the site of Avebury.

There were, according to Martin, financial and altruistic reasons for his concentration over the next few years on producing prints. Because of the labour spent on them, his paintings could not be sold for less than £1000 or £2000. Very few collectors could afford to pay such sums or were willing to pay them for Martin's work. Furthermore, the public was not able to see the paintings when exhibited because of the abominable way in which they were hung. In 1826, therefore, the first of Martin's large mezzotints appeared. According to the announcement in *The Literary Gazette* of June 10, *Belshazzar's Feast* 'was ready for delivery, Proofs, 5 guineas, Prints £2. 10s.'

Having gained so much experience from the two sets of plates for *Paradise Lost,* Martin was able to see exactly what the new medium was capable of. Soon after the exhibition of the painting he had decided to publish an engraving of it, and started on a copper-plate, but in 1822, experiments in steel engraving had borne fruit, and Thomas Lupton had been awarded the Isis Medal by the Society of Arts for his soft steel plate. Martin had sought his advice and help on the use of his technique for the *Paradise Lost* mezzotints which were all executed on steel, from which impressions were to be pulled for another forty years. He now produced 'the first large steel plate ever engraved in mezzotint'.

Belshazzar's Feast was followed by *Joshua Commanding the Sun to Stand Still,* dedicated to Prince Leopold of Saxe-Coburg. An advertisement in *The Literary Gazette* explained that Charles Turner had not completed the commission accepted in 1817 to engrave the oil painting, Martin having decided to produce a new steel plate himself.

The receipts from June 1826 to December 1827 from these two prints alone were almost £3000. However, as Martin was his own printer and publisher for these and the following four large mezzotints, there were overheads to be deducted, although the major expense of a press and other equipment had been taken care of soon after the Egyptian Hall exhibition, when he had built a well-equipped painting room and studio in his house.

Leopold gives a detailed description of Martin's working habits in the printing room, which provides an insight into the time and trouble Martin took and the technical skill he had acquired over a very few years. The quality of the finest impressions is no doubt due to a certain extent to Martin's chief printer, a man called Wood, whom Martin had lured away from J. Lahee the printer of some of the plates to *Paradise Lost,* but mostly due to the experimentation with the steel plates and ink.

'At the outset he would pull a plain proof of the plate, using ordinary ink; then work or mix the various inks. First he made a stiff mixture in ink and oil; secondly, one with oil and less ink; and thirdly, a thin mixture of both ink and oil. Lastly, he worked up various degrees of whiting and oil with the slightest touch of burnt amber, just to give a warm tint to the cold white. In working or inking the plate, the thick ink (No. 1) went to the darkest tints, No. 2 to the medium ones, No. 3 to the lighter shades; the inks consisting chiefly of whiting, the most difficult to work, and the most artistic. Separate dabbers were required for each description of ink. The greatest attention was needed in the use of canvas when wiping off, so as to blend or harmonize the various inks, especially those of whiting. This blending or harmonizing was really quite an art, quite a task of great skill, only to be acquired from the engraver.'

Not only would Martin experiment with the inking of the plates, but also, at the risk of destroying weeks of work on the plate itself, would not hesitate to etch some area of the plate with new acid if the effects were not quite what he wanted. It is understandable, therefore, that only about eight to ten impressions could be taken in one day. A printing of the complete edition of *The Deluge* took not less than eleven weeks.

The next mezzotint was not *The Destruction of Pompeii and Herculaneum* as advertised, which was never engraved, but *The Deluge,* published in September, 1828 and dedicated to Nicholas I of Russia. It was accompanied by a descriptive catalogue , as was the painting of two years earlier. The other large mezzotints were *The Fall of Ninevah,* 1830; *The Fall of Babylon and Satan in Council,* 1831; the second plate of *Belshazzar's Feast* and *Pandemonium,* 1832; *The Crucifixion,* 1834; *The Destroying Angel* and *The Death of the First Born,* 1836; *Marcus Curtius,* 1837; and *The Eve of the Deluge,* 1842. As well as these, which met with varying degrees of success, and the other smaller mezzotints published independently, Martin also contributed prints and designs to various annuals, the first being *The Amulet* in 1826, in which two small mezzotints of Biblical subjects appeared.

Martin's work was also published in five other annuals: *Forget Me Not, Friendship's Offering, The Literary Souvenir, The Keepsake* and *The Gem* These small, thick volumes grew in popularity from the appearance of Ackermann's *Forget Me Not: A Christmas New Year's Present for 1823* until the early thirties. Twenty-seven of Martin's designs appeared in the various annuals between 1826 and 1837, of which three were engraved by himself. His *Alexander and Diogenes,* engraved by E. Finden, was the third best selling print issued independently by *The Literary Souvenir.*

In the autumn of 1827, the year of Delacroix's *Death of Sardanapulus,* Martin started on his next large picture of the same subject, *The Fall of Ninevah,* which was exhibited alone the following year at the Western Exchange, Old Bond Street, from May 12th through September. Admission was one shilling, and for the same price there was a sixteen page descriptive catalogue in the usual format. Subscriptions were also invited for a large mezzotint of the paintings which Martin was shortly to publish.

Although the painting did not sell (the alleged price was 2000 guineas), it was well received by both public and critics and went on tour throughout England. On its return Earl Grey commended it to William IV who saw it at Buckingham Palace, having nothing more to say than 'How pretty'. Three years later, it received the Gold Medal at the Brussels Salon, where Martin had been invited to exhibit by his friend, now King Leopold of the Belgians. As he was not permitted to purchase the painting, he invested Martin with the Knighthood of the Order of Leopold and had him appointed a member of the Brussels and Antwerp Academies. That Martin thought *Ninevah* one of his most important paintings is attested by the guest list for the Private View at the Western Exchange, where the 2500 guests invited included 'Foreign Ambassadors, Earl Grey, Lord Durham, Sir Walter Scott, Sir Thomas Lawrence and the Principal Artists and Academicians.'

Martin's fame at this point in his life is well-documented by Leopold and contemporary diarists. As well as his inclusion as the only artist in *Public Characters,* biographies of fifty-four prominent public figures, there was also a lengthy review of *Lives of the Most Eminent Painters* by Alan Cunningham in *The Edinburgh Review* of March 1829, which was nothing more than a critical eulogy of Martin's work to date, notwithstanding the usual adverse comments about his handling of facial expression. A similar eulogy appeared in Edward Bulwer-Lytton's *England and the English* four years later.

This was therefore the height of Martin's career. Handsome, well-dressed, but no longer the dandy of a few years earlier, vociferous, but always charming company despite his somewhat radical political stance, he was always in the best company. His studio was visited by royalty and men and women of letters, as well as by artists, scientists and theologians. His weekly evenings, originally a gathering of chess enthus-

iasts, became after 1825 regular forums for all kinds of discussions, and were attended by the Landseers, Jane Webb (authoress of *The Mummy*), Wheatstone, Leigh Hunt and other literary talents. At the same time Martin was expected to return their visits. Turner and Constable, rival and critic respectively, both received him cordially. He was a regular guest at Sir Robert Peel's home and George Cruickshank invited him to dinner to meet Dickens, with whom he quickly became friends. But in the same year that Martin was hard at work on *The Fall of Ninevah,* he also embarked on a project which would concern him until a few years before his death and at one point would almost ruin him financially.

Before 1827 there are few references to Martin's involvement with engineering projects, inventions and the like. An early influence in this field could have been John Dobson, a fellow student of Martin's in Newcastle under Boniface Musso. He was two years Martin's senior and became an important architect in the planning of Newcastle. Martin also helped his brother William win a silver medal and ten guineas from the Society of Arts when he drew an improvement for the weighing machine which William had invented. Finally, the designs for the memorial bridge across the New Road, exhibited in 1820, witness his aesthetic interest in large scale architectural projects.

The problems with which Martin became involved mostly concerned the improvement of London's amenities, in particular the supply of the city's water and sewage disposal. His first *Plan* appeared in 1827, eleven others following before the last in 1850, but they were mostly improvements upon or variations of the initial idea, which was to bring water from the Colne to supplement the supply from the New River. There were also other pamphlets concerned with mine and maritime safety.

As well as the published *Plans,* Martin proposed his ideas before the various Select Committees on Metropolis Water and the like and in 1834, he put forward the idea which was eventually adopted, which was to take water from the Thames above Teddington Lock. Martin admitted at the time that rather Gilpenesque aesthetic ideas had been the initial impulse for his schemes, and both practical and aesthetic considerations abound in all the *Plans.* Along the various watercourses are an aqueduct, a swimming pool, ornamental lakes, and waterfalls. The aqueduct was to carry railway tracks above it, which would be cambered so that trains could take corners at speed - an extremely novel innovation at the time. The 1832 *Plan for Improving the Air and Water of the Metropolis* introduced another proposal which was again only adopted after his death, whereby sewers were laid parallel to the river Thames; above them would be quays and 'where there is anything disagreeable and unsightly, such as a coal-wharf, a Colonnade or Arcade should be erected'.

Although the Select Committees listened patiently to the *Plans,* which were also met with approval in the pages of *The Builder,* they met with most success when considered by a voluntary and private committee brought together in 1836 after the Institute of British Architects had also given its support.

The Committee, chaired by Lord Euston, included four Members of Parliament, eighteen Fellows of the Royal Society (Faraday and Wheatstone among them) and six Royal Academicians (including Etty, Turner and Eastlake). Their report found that 'it was given to the genius of Mr. Martin to devise the simplest as well as the most completely effectual' of the many plans considered. The 1832 *Plan* was then quoted in full with some improvements, of which the most innovative was that the roofs of the quays would provide 'a magnificent Promenade, unequalled in Europe, to which the Public would be admitted gratuitously on Sundays and at the smallest rate of charge on every other day of the week. The brilliant illumination by gas of the great walks, and if necessary of the wharfs, is calculated to secure the protection of property on the river by night'.

The present Victoria embankment, a meagre shadow of Martin's original scheme (revised and republished in 1842) for the whole of the Thames from Greenwich to beyond Hammersmith Bridge, was eventually built between 1864 and 1870 to the designs of Sir Joseph Bazalgette.

In 1846 Martin managed to promote the Metropolitan Sewage Manure Company which was allowed by Act of Parliament to lay the proposed sewers under the banks of the Thames. But faced with many difficulties, especially from members of the board of the Company and the Navigation Committee, he resigned from the directorship, and the Company was wound up in 1850 before any attempts at construction had been made. Given that the *Plans* are related architecturally to his paintings and mezzotints, it is highly probable that Martin's artistic output had an influence upon other architects and engineers, although there is no concrete evidence of this. It is possible that Brunel's proposal for the Clifton Suspension Bridge in 1829 owes something to Martin's Biblical compositions. Yet the Egyptian

revival at the turn of the century was very widespread, as evidenced by the architecture of Boullée and Ledoux, the stage sets for *The Magic Flute* by Schinkel (and Quaglio) and the Egyptian Hall, where Martin exhibited, to name just a few instances.

However, although they are not mentioned as being friends at the time, Martin and Brunel had friends in common, and would certainly have been aware of each other's work. Martin especially would have noted the progress of the Thames Tunnel to the workings of which the public were admitted for the first time in 1827, when gas-lit banquets were held there. He was furthermore concerned with railways throughout his *Plans,* and it is not surprising to hear of him accompanying Brunel with Wheatstone and Leopold in 1841 on a speed test of a broad-gauge locomotive. It took place on the main line of the Great Western Railway and the nine miles between Southall and Slough were run at 90 m.p.h. It was only a few years later that Martin moved into Lindsey House where Brunel had been living.

Contemporary engravings illustrating tunnels and mine workings often bear remarkable similarity to Martin's architectural compositions, in particular a view of the railway at Edge Hill, Liverpool, in 1831, showing the entrance to the three tunnels bounded by high walls, as in *Belshazzar's Feast.* However, the engraver was equally open to other influences, for instance in his choice of the perspective view.

In this context, the most striking of the *Paradise Lost* illustrations is *The Bridge of Chaos* where Martin deviated slightly from Milton's text and made the bridge into a causeway, not unlike the aqueduct hewn from the rock, and set it inside an immense tunnel. Iconographically the image derives for example from Bosch's depiction of *The Ascent into the Empyrean* through the Divine Spheres. The years covering the height of his interest in the *Plans* were almost financially disastrous for Martin and his family. He spent many thousands of pounds on them without benefiting from any income which they might have provided. In 1837, he was a 'ruined crushed man' and the following year his wife thought he was going mad. There had been other problems to contend with. Not only had his *Plans* been plagiarised in the many other proposals by his contemporaries, but his paintings and engravings were experiencing similar piracy on a greater scale.

During the ten years from 1828, Martin was supported mainly by the income from his prints and designs. On July 3, 1830, the largest mezzotint he ever engraved, *The Fall of Ninevah,* was finally published, after five months of continual work. The previous large prints were still selling, and his income was reasonably constant because of it. But his next project, started in 1831, was a serious drain on his energy and not particularly profitable.

Inspired by Prowett's *Paradise Lost* venture, Martin decided to publish himself the *Illustrations of the Bible.* The last parts to the Old Testament appeared in 1835, and the proposed New Testament plates were never engraved. Though the prints themselves were fine, the manner in which the parts were put together and the badly designed pages and letterpress caused the public to neglect them. Martin sold his remaining stock of engravings and the plates to Charles Tilt who republished them in a folio album in 1838 and in a smaller format in 1839.

In 1833 Martin exhibited his first paintings for five years, *Leila,* a scene from Byron's *The Giaor,* and *Alphaeus and Arethusa* (dated 1832), at the Institute. The large mezzotint of *The Crucifixion* followed in 1834, and in 1835 two oil paintings, now lost - *Judith Attiring* and *David Spareth Saul at Hachilah* - plus four watercolours, including *Stanmer Church,* were exhibited at the British Artists.

However, also in 1835, the first parts of the *Illustrations to the Bible* were published by Bull and Churton who had commissioned designs from Westall and Martin the previous year. They divided them equally between themselves and each of the twelve monthly parts consisted of eight wood engravings by various engravers and a page of description by the Reverend Hobart Caunter. The venture was highly successful and added a great deal to Martin's fame throughout the 19th century, as Churton proceeded to publish in the same format the *Illustrations of the New Testament,* and they saw various later publications by different publishers in the same way as those for *Paradise Lost.*

Despite all this activity, Martin still managed to find time to appear three times in 1835 before the Select Committee on Accidents in Mines, and the Select Committee on Arts. He appeared before the latter body again in 1836, the two major grievances under discussion being the Royal Academy and plagiarism. In 1833, the Queen's Bazaar in Oxford Street had shown 'Mr. Martin's Grand Picture of *Belshazzar's Feast* painted with Dioramic Effect.' The diorama was a blatant unauthorised copy of his masterpiece. '. . . a most infamous piece of painting and the public were given to understand that I was the painter; this was ruining my reputation', he complained to the Committee, 'and at the same time taking from me that

which ought to be my own by copyright'.

There is further evidence of plagiarism where his prints are concerned. There were many pirated editions published not only in England but also in France and Germany. There were also emulators of his style, S. Lucas being one of the more successful ones, who had mezzotints of *Samson Carrying off the Gates of Gaza, The Destruction of the Cities of the Plain,* and *The Triumph of Achilles* published by Rittner and Goupel in Paris. However, the copyright which Martin recommended to the Select Committee was not adopted, and Martin stated in 1849 that he 'was eventually obliged to abandon [engravings] owing to the imperfect laws of copyright, my property being so constantly and variously infringed that it became ruinous to contend with those who robbed me'

Martin was highly critical of the Royal Academy throughout his life; the antipathy was mutual. Before the Select Committee he recounted his grievances in detail, beginning with the incident with his *Clytie* on varnishing day in 1814. His paintings had been hung in 'such disadvantageous positions as to do me great injury', he said. Only two were not hung in the Ante-room, and even then were either too high or in the dark. He complained that Royal Academicians or Associates of the Royal Academy had an alloted number of positions, and that outsiders were not given a fair chance. Furthermore, portraits, which were usually commissions and therefore already paid for, were given the best positions, and accordingly the historical paintings suffered greatly.

These were among the reasons for his attempting to get better treatment at the British Institute. But there he found the Academicians still appeared to monopolize the choice places and adding insult to injury, sent the portraits of the previous year's Academy show, giving them fictitious titles as the Institute professed not to accept portraits. In the end, it would seem that the Institute was preferable only because of its premium and an open varnishing day.

Martin's views were shared and supported by Haydon and John Linnell and the Committee accepted his criticisms despite the defence of the President of the Royal Academy, Sir Martin Archer-Shee, who pointed out that in financial terms Martin was as successful as any Academician. Yet this was probably one of the major points of contention, since Martin, who had had no formal instruction at a teaching institution, was able to command prices which many Academicians after years of training in Antique and Life Schools would never be able to ask. C. R. Leslie, who had been a good friend of Martin before becoming an A.R.A., published some scathing criticism of Martin's paintings by other Academicians during his lifetime in his *Life of Constable.* And Bulwer wrote: 'I never met with an Academician who did not seem to think you insulted him by an eulogy of Mr. Martin'.

The next two years were extremely difficult for Martin and his family, whose finances were at their lowest ebb. Loans had not been repaid by his solicitor and his brother Richard, and Martin felt he had been 'plundered and deceived'. On top of these hardships, his nephew Richard, Jonathan's only son, who had been living with them, committed suicide. Even his remaining plates were in pawn with Phillips, the auctioneer. *The Deluge,* re-exhibited in 1836, had not sold. The history of his other Academy pictures from this date is unknown.

It is possible that too much emphasis is given to *The Coronation of Queen Victoria* as the cause, but things became noticeably improved around 1838 while he was at work on the painting. More commissions came in, the most important being *The Eve of the Deluge* and *The Assuaging of the Waters,* both exhibited at the Academy in 1840. He was able to afford a descriptive pamphlet for *The Deluge* trilogy and reclaimed his *Plans,* which were still to occupy him for a further ten years.

However, he continued to exhibit more regularly. In 1842 there were seven paintings at the Academy, mostly landscapes, and *Curfew Time* at the Institute. *The Eve of the Deluge* had been delivered to the Prince Consort the previous year, and now his final mezzotint of it appeared, dedicated to the owner. That his social status had not deteriorated during the period of his troubles is witnessed by his daughter Zenobia's wedding that year to Peter Cunningham, at which 'all literary and artistic London' were present in St. George's, Hanover Square.

In 1843 *Goldsmith's Hermit* was shown at the Institute and his unsuccessful cartoons for the decoration of the new Houses of Parliament at Westminster Hall, as well as a large related picture of *Canute* at the Academy, accompanied by *Christ Stilleth the Tempest,* both criticised by Ruskin in *Modern Painters.* By 1848 Martin had sold all but one of his large paintings and had ceased engraving. Of his children, only Isabella remained with him and his wife at Allsop Terrace, and as there had been a rise in the rates, they decided to move to Lindsey House, by the Thames, where they settled on August 13.

After his move he produced until his death a steady flow of watercolours of the nearby London beauty spots - Richmond, the Thames, Twickenham - some of which he regularly exhibited. A second version of *Joshua* was exhibited in 1849. He was still writing his *Plans,* mainly to establish himself as the originator of plagiarized ideas. He also published a long autobiographical letter in *The Illustrated London News* of March 10. The family was joined from Newcastle by Martin's brother Jonathan who died fifteen months later. During the last years after moving to Lindsey House, Martin, now in his sixties, spent a good deal of the summer and autumn months on the Isle of Man, staying mostly in Douglas with Thomas Wilson, a relation by marriage.

His last exhibited paintings were an oil and two watercolours in the Academy in 1852, but by this time he was at work on the first painting of his second trilogy and last works - the *Judgment* pictures. This was *The Last Judgment,* which he arranged to have engraved and published by Thomas Maclean, who had a gallery in the Haymarket. Before the painting was finished he had conceived and commenced two companions, *The Great Day of his Wrath* and *The Plains of Heaven,* again based on Revelations, and to be published as engravings by Maclean under the same terms as the first.

The trilogy was completed before Martin left Lindsey House for Douglas for the last time. There on November 12th, 1853, he suffered a paralytic seizure while painting. He lost his sight and the use of his right hand, but his mental faculties remained intact. He was soon unable to use any of his limbs. According to the *Athenaeum* 'he ceased to take food except in the very smallest quantities, giving his attendants the impression that in so doing he was acting upon some principle which he had accepted in his own mind, though he had no longer the power to explain the why and wherefore' since he had not spoken since the attack.

On December 26th he signed his will with a cross, but was to live on with only the comfort of his thoughts until February 17th, 1854, when at six o' clock 'he passed away without effort or apparent pain, and was conscious to within an hour of his death. He seemed perfectly aware that he was dying, but to have no fear of death.' Martin was buried at Kirk Braddan Cemetery in Douglas on February 24th, in a private vault, where a marble slab was inscribed 'In memory of John Martin, Historical Painter; born at Haydon Bridge, 19th July, 1789; died at Douglas, Isle of Man, 17th February, 1854'.

The Judgment pictures were a final and grand salute to Martin's genius and life work. They toured this country and America. Both the public and critics were excited by their grandeur and they were described by Mrs. Henry Wood in *East Lynne*, published in 1861. However, the income from them and Martin's whole estate was not sufficient to support his widow and Isabella, and the contents of Lindsey House were auctioned along with his watercolours at Christies in July, 1854.

Martin had been set up during his lifetime as a rival to Turner. However, their rivalry was confined to popularity rather than quality. It was his imagination that thrilled the public, as even his most ardent supporters criticised his execution, especially his use of colour. Ruskin's attacks were among the most vicious. Having discussed Turner, he continued: 'Martin, on the contrary, whose chief sublimity consists in lamp black, never made a design yet, which the eye could endure if reduced to a small size'. And elsewhere he asks: 'If black and red were not productive of the sublime, what would become of the pictures of Martin?' Thackeray, who preferred Danby, found the *Eve of the Deluge* and *The Assuaging of The Waters* 'huge, queer and tawdry'. To Constable, *Belshazzar's Feast* was 'pantomime' and both Martin and Danby classed as painters of 'phantasmagorias'. He also recorded in 1823 that Northcote, who considered Martin's pictures 'mere tricks' and not 'historic art,' suggested to Turner that he was imitating Martin. Apparently Turner often later spoke of this story as a good joke.

Though no two *oeuvres* are less alike than Martin's and Turner's, they both learnt from each other's work. Martin closely observed Turner's early paintings - *The Destruction of Sodom, Fall of an Avalanche in the Grisons, Snowstorm: Hannibal and his Army Crossing the Alps.* They clearly show the kind of vision which Martin appreciated, yet they equally clearly mark the differences between the two.

Both artists can also be seen as inheritors of the traditional subjects of the latter part of the eighteenth century, and one only has to look at a list of West's Academy exhibits to see the genre that Martin in particular fitted into.

He was not alone in the somewhat bizarre off-shoot of the Academic style for which he is remembered; there were lesser artists about whom more is gradually being learnt. Joseph Gandy, assistant to John Soane, showed architectural fantasies like *Pandemonium* and a coloured drawing of what he imagined the Rotunda of the Bank of England would be like in ruins! Samuel Colman was probably closer to Danby,

but certainly influenced by Martin in, for example, his anachronistic *The Coming of the Messiah and the Destruction of Babylon,* where Martin's Tower of Babel is split in two by lightning. His fellow Bristol artist Paul Falconer Poole, who was also a follower of Danby, painted *The Destruction of Pompeii* after his move to London.

Martin's influence on painters in America, particularly upon the English-born Thomas Cole and Washington Allston, is a little studied area. Cole was in England from 1829 to 1831, and again a decade later. He knew Martin, as did Allston, through C. R. Leslie, and was present at one of Martin's 'evenings'. It would appear that he was familiar with the *Paradise Lost* illustrations, as well as the large mezzotints and paintings of Biblical scenes, especially from the *Architect's Dream* and his several large series, *The Voyage of Life,* and *The Course of the Empire.*

Though Allston has been mentioned as an influence on Martin, that he was also impressed by the latter's works when in London is reflected in *Elijah Being Fed by the Ravens,* which he painted on his return to America in 1818.

Unfortunately no contemporary accounts of the *Judgment* pictures have appeared to throw light on the success of the tour in America, but by that time the nationalistic school of the realistic-sublime epitomized by Bierstadt, Church, Heade and Durand was flourishing, and interest taken by painters in Martin's work must have considerably lessened.

Martin's paintings exerted some influence on various writers both in England and abroad throughout the 19th century. Shelley's *Sadak the Wanderer: a Fragment* is one of the earlier examples. Bernard Barton's poems appeared in the annuals and in Martin's pamphlets, as well as those of other lesser poets. Bulwer-Lytton probably took some inspiration from Martin in his *Last Days of Pompeii.* Finally, the Brontes's admiration for Martin is evidenced by descriptions of Haworth Parsonage. Their favourite print, *Belshazzar's Feast,* hung on the parlour wall, throws an interesting sidelight upon Charlotte's biographical note to *Wuthering Heights* in 1850. Watercolours after Martin are described along with Charlotte's drawings of *Angria* and *Glasstown* and Branwell's early watercolours as revealing a predilection for Martin's wilder fantasies.

Mention had already been made of Martin's success abroad. He was made a member of the Brussels and Antwerp Academies, awarded a Gold Medal in 1829 by the Paris Académie des Beaux Arts, and in 1848 was appointed a Knight in the Academy of St. Luke in Rome, an exceptional honour for an artist who had neither studied nor exhibited in Italy.

His reputation in France was such that in 1834 Michelet classed him with Bentham and Maturin as archetypically English, and the adjective *'martinien'* was in common use during his lifetime. Pirated editions of his prints were published there, as well as Lucas's copies. Martin's influence can be seen in Hugo's *Orientales,* particularly in *Le Feu du Ciel.* Gauthier was not always complimentary but he described *Belshazzar's Feast* in 1837 as 'une ode architecturale pleine de lyrisme, avec des strophes de porphyre de et jaspe, et dont chaque vers est une superposition de Babels . . .' Balzac used *'martinien'* similes, but the accolade was given by Berlioz, who in 1851, having returned from a service at St. Paul's, dreamed of the Charity Schoolchildren who had sung *All People that on Earth Do Dwell,* transformed into 'la mise en scène du célèbre tableau de Martin', which could only be *Satan Presiding at the Infernal Council.*

Whatever the influences Martin experienced, whether the English landscape tradition derived from Salvator and Claude, Turner, or Northumberland and the industrial landscape as portrayed by de Loutherbourg, Wright and others, there can be no doubt that he was a genius and according to *The Observer* obituary, one 'whose originality of conception has startled all Europe' and in the light of the *Judgment* pictures 'snatched from us in the full strength and maturity of his powers'. It concluded by classing him with Hogarth and Flaxman as an artist who 'convinced the world that in the fine arts as in poetry, Englishmen are capable of all that is great and beautiful'.

The Illustrated London News was more sweeping in its praise: 'Yes, John Martin was in every respect a great and original artist. His honourable hereafter is secure in the annals of English art. No man is safer, for he was great in more ways than one. Like Hogarth (that great original) he was the engraver of his own works. Of no other artists can it be said that they were equally excellent as painters and as engravers.' History did not uphold its judgment. Recent years have seen, for example, the engravings of Gainsborough come into great favour, and a brief look at exhibition catalogues and auction prices, shows how long it

took for Martin to regain any popularity. In the Naylor-Leyland sale of 1923, Martins were knocked down for a few pounds, *The Deluge*, £6, *The Fall of Jericho* (presumably the second *Joshua*, mistitled), £10, and *The Fall of Ninevah* was apparently bought in. The *Judgment* pictures fared even worse. As for exhibitions, Ford Maddox Brown complained that Martin was excluded from the supposedly representative 1887 Jubilee Exhibition in Manchester, and similarly E. Wake Cook protested against his exclusion from the Royal Academy Winter Exhibition of 1901. He was not admitted to the Academy until 1957, where all his paintings except a small watercolour were abominably hung.

Perhaps it is only now, with an extra half century or so of hindsight, that it is possible to appraise Martin's contribution not only to British and European art, but his influence in other fields, and the esteem in which he was held during his lifetime.

Martin's career is more akin to that of a Renaissance humanist than to a 19th century painter. His unceasing activity in every field available to him, enabled him to capture the imagination of the whole spectrum of the public during his lifetime and since. His vision was reflected not simply in his paintings, but upon the environment with which he was so much concerned.

To have successfully reorganized the metropolis of London as he had proposed would have been too great a feat for ten men. It is enough to have his *Plans* and to realize that he had the foresight to envisage a city whose population would grow to ten millions in only two generations.

His aim as a painter is probably best summed up in his own words, taken from the prospectus for the *Illustrations of the Bible:* it was to avail himself 'of all objects afforded by inanimate nature, as well as by the passions and ingenuity of man, by bringing before the eye the vast and magnificent edifices of the ancient world, its forests, wilds, interminable plains, its caverns and rocks and mountains, by freely employing the aid of its powerful and primitive elements of fire and water, which, when agitated by their Almighty Disposer (using the language of the poet) "between the green sea and the azure vault sets roaring war." '

THE LAST JUDGMENT PICTURES

The Last Judgment, the largest of Martin's paintings except *The Fall of Ninevah* was begun early in 1851, and on June 7 of that year Martin signed an agreement with Thomas Maclean, a printseller on Haymarket, to the effect that Maclean would find a mutually acceptable artist to engrave the picture, Martin would take a third of the net profit from the sales of the prints, and Maclean was to have the right to exhibit the painting at his expense with a view to increasing the orders for the engraving. Mottram was given the commission and must have had the painting before the end of the year. However, the order was post-poned because by this time Martin was already working on two companion pictures: *The Great Day of His Wrath* (originally named *The End of the World* and *The Plains of Heaven*). A second agreement with Maclean was signed on June 23, 1852, the terms being identical with the first.

All three paintings were finished before Martin left for the Isle of Man in October, 1853. The many pentimenti apparent in *The Last Judgment* show that Martin had more trouble with it than with the others. The engraving was probably postponed due to his changing conception of the scene, and it is dated 1853, despite Mottram's having started on the engraving the previous year. When finished it was exhibited at Maclean's where it was noticed in *The Art Journal* of July with some ambivalence.

The painting is Martin's conception of the scene at the sounding of the last trump: God is flanked by twenty-four elders and Angels; the Avenging Angel is below: on the right are the damned, while on the left on a hill across the Valley of Johoshaphat are the righteous. Among the latter are portraits of famous men throughout history (recalling James Barry's cycle *The Progress of Human Culture* of 75 years earlier), including the painters: Michelangelo, Wilkie (died in 1841), Leonardo, Raphael, Titian, Rubens and Dürer.

The Great Day of His Wrath is based on Revelations vi:

And I beheld when he had opened the sixth seal, and, lo, there was a great earthquake,
And the heaven departed as a scroll when it is rolled together; and every mountain and island were moved out of their places . . .
For the great day of his wrath is come; and who shall be able to stand it?

Leopold was to write after Martin's death that the painting was inspired by a journey through the black country at night where 'The glow of the furnaces, the red blaze of light, together with the liquid fire, seemed to his mind truly sublime and awful. He could not imagine anything more terrible even in the regions of everlasting punishment. All he had done or attempted in ideal painting fell far short, very far short of the fearful sublimity.'

The Plains of Heaven is again based on Revelations, this time chapter 21. 'And I saw a new heaven and a new earth: for the first heaven and the first earth were passed away; and there was no more sea.
And he sat that upon the throne said 'Behold, I make all things new.'' '

The first exhibition of the *Judgment* pictures for which there are records was at the Victoria Rooms, Grey Street, Newcastle. The exhibition opened on February 10, 1854, seven days before Martin's death, and *The Newcastle Chronicle* gives them their first notice: 'The three pictures are fine examples of this

descriptive skill of Martin. *The Great Day of His Wrath* and *The Plains of Heaven* are the Antipodes of his style. In one he congregates everything which in a picture could inspire dread. The earth opening, mountains falling, and nations in suppliance before the Power which reds the globe. In the other the eye is pleased with the smooth azure-surfaced lakes, the vistas of light gleaming, through the trees, rills sparkling down the mountain-side, and the seraphic beings by the borders of the lake enjoying the music of their harps, while far distant the turrets of the city of the Great Kings are faintly seen. The effect of *The Last Judgment* is rather marred by the introduction of the complete series of events attending its Scriptural description. The overflow of the armies of Gog and Magog on the one side of a gulf, with the resurrection of the good of the earth on the other, are obscured by the flat platform of clouds above, on which is seated the tribunal of the angels. The eye cannot embrace such a mass of detail at once neither can the mind feel the terror of the destruction of the wicked, combined with the beatitude of the good, when in conjunction with the judgment which determines their fate.'

The paintings finally reached London in 1855, after touring the major provincial towns, including Oxford, Birmingham, Leicester, Bristol and Chester. They were exhibited at the Great Hall of Commerce, Threadneedle Street, by Leggat, Hayward and Leggat, and a four-page sheet advertising them described them as 'the most sublime and extraordinary pictures in the world', giving their value as 8,000 guineas.

The Morning Post of May 3, 1855, wrote: 'The three last and certainly greatest painting ever executed by that original genius, Martin, are now on view, and well deserve the attention of all persons interested in the extraordinary efforts of art. The simple grandeur of the conception, the broad artistic arrangement and the wonderfully inventive faculty in detail, displayed in these sacred illustrations will serve to place the fame of Martin in a much higher position than any of his former labours'.

The Illustrated London News (May 6) was equally appreciative: 'The subjects of these works are sublime mysteries which the artist has treated with a boldness of fancy, a grandeur of invention, and a mastery of resource which none but himself could command. At the touch of his pencil as of a magician's wand, earth and heaven are riven, resolved, as it were, into chaos, out of which a magnificent structure of his own creation is reared. The subtle philosophy and deep morality which mark all the incidents of his marvellous creation are not the least important and gratifying evidence of his genius.'

However, the artistic community, whose opinions were expressed by *The Art Journal,* which had been ambivalent about the *Last Judgment* in 1853 was outraged, and after citing Michelangelo's 'profound awe' when approaching the subject, states that Martin 'allowed his imagination to revel amid its wildest fancies till it extended into the region of burlesque, and almost into that of profanity'. The writer then excuses the artist whose mind was 'no doubt, thrown off-balance during the last years of his life when these pictures were painted' but not so 'the public who follow eagerly after such things. Surely there is something most unhealthy in this exhibition of the public taste, this craving after novelty of the most extravagant kind.'

The engravings 'in the mixed style' by Charles Mottram were finally published on January 1, 1857, the complete stock of prints being sold out within a few years, and the plates cancelled. The paintings themselves, which had been withdrawn from exhibition so that the engravings could be completed, were sent on tour in the United States, but were back in London by 1860 where they were exhibited in the Strand but apparently raised little interest. Lithographs were also published by James Stephenson. However, the paintings again went on a provincial tour when *The Newcastle Courant* reported them at Hexham in 1872: 'It is the custom of the owner not to exhibit these treasures in any town under 30,000, but the inhabitants of Hexham have been so singularly favoured because Martin was born among them'. A further set of small mezzotints was published in 1870 by C. Mitchell of Bristol. And before the end of the century they were exhibited in Montreal and Earls Court (1897) and in 1906 had even been mortgaged by one of Martin's descendants.

In 1935 the three paintings fetched £7 between them when bought by Mr. Rex Nan Kivell, scotching a plan by some dealers to cut them up into small pictures. *The Last Judgment,* was in fact soon afterwards cut into four strips to decorate a screen, but has been restored to its original state with no deterioration in quality.

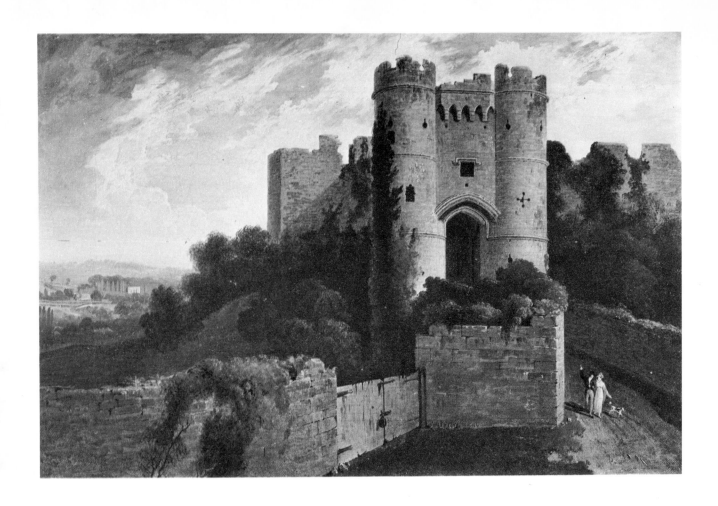

VIEW OF THE ENTRANCE TO CARISBROOKE CASTLE 1815
Oil. 32.4 x 45.1
Signed 'J. Martin 1815'
Private Collection
Exhibited with 'Carisbrooke Castle' at the British Institution in 1815 this was one of several views in the Isle of Wight painted by Martin on sketching holidays. Carisbrooke is the principal castle on the island, most of which dates from the 13th to 16th centuries. This view shows the massive gatehouse of which the outer part and round towers were built circa 1335-6.

CLYTIE 1814
Oil. 61 x 91.5
Signed 'J. Martin 1814'
Private Collection
Martin sent a large painting of *Clytie* to the Royal Academy in 1814 with the following quotation from Ovid's *Metamorphoses*: 'All day all night in trackless wild, alone she pin'd, and taught the listening rocks her moan'. On varnishing day an Associate or Academician spilt varnish down the middle of the composition, and it was completely ruined. Martin later repainted it, altering the subject to *Alpheus and Arethusa* (collection of the Earl Howick of Glendale). This version might have been done after the accident occurred as no attempt had been made to clean the original. Clytie was an ocean nymph, beloved by the Sun-God who deserted her. She was changed into a heliotrope, a flower which is supposed to turn its head in the direction of the sun's movement.

Overleaf

DISTANT VIEW OF LONDON 1815
Oil. 17.8 x 30.5
Signed 'J. Martin 1815'
Glasgow Art Gallery
With *View of the Entrance to Carisbrooke Castle* this is the earliest known oil landscape by Martin. St. Paul's Cathedral and other recognizable buildings can be faintly seen in the distance.

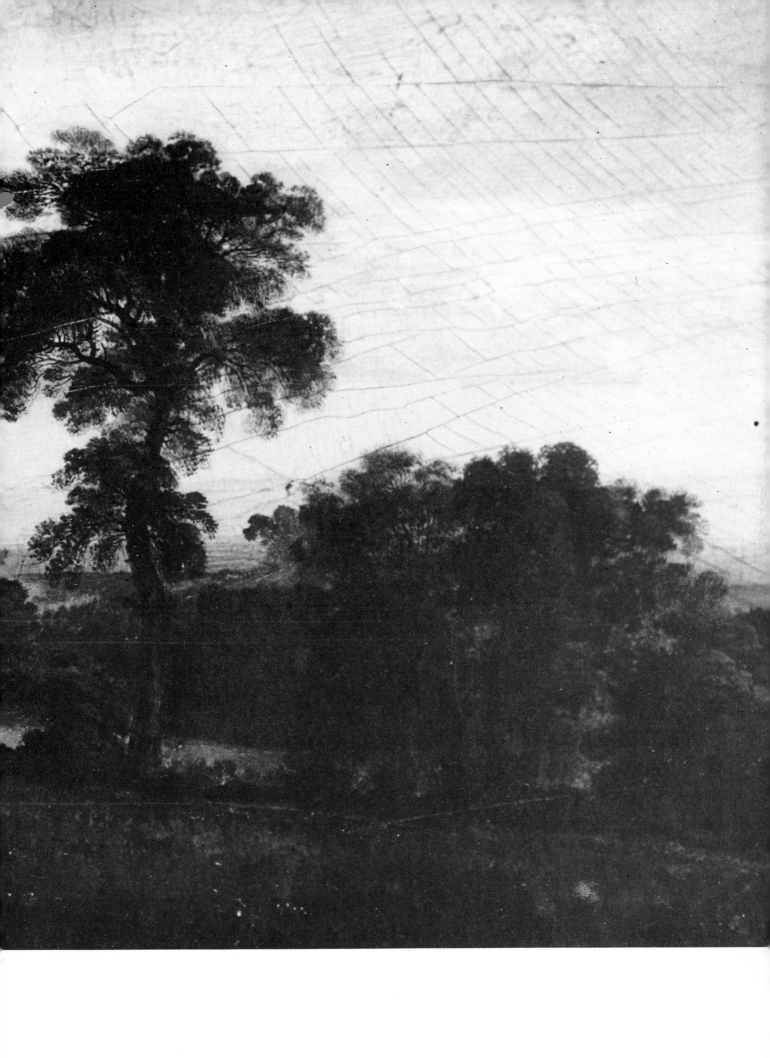

THE BARD 1817
Oil. 213.4 x 155
Not inscribed
Laing Art Gallery

An illustration of *The Bard* an ode by Thomas Gray published in 1757, telling of Edward I's attempt to prevent the Welsh from keeping alive the spirit of resistance by condemning all the bards to death. In Martin's picture the last bard curses Edward I from a rock high above the Conway River, before hurling himself to his death in the torrents below. Although the tradition is now discredited, the several depictions of the subject showed a revived interest in British history towards the end of the 18th century: among them are those by Sandby in 1760, Thomas Jones in 1774, Blake circa 1794 and Fuseli, published in 1800. A drawing attributed to de Loutherbourg, who published an engraving of the subject in 1784, is very close to Martin's figure of the Bard. A related drawing by Martin, *Orpheus with his Lyre,* is in a private collection.

The painting was exhibited at the Royal Academy in 1817 with a quotation from the poem:

Ruin seize thee, ruthless King.
Confusion on thy banners wait;
Tho' fanned by Conquest's crimson wing,
They mock the air with idel stare!
Helm, nor Hauberk's twisted mail,
Nor even thy virtues, Tyrant, shall avail
To save thy secret soul from nightly fears,
From Cambria's curse, from Cambria's tears!

Gray's description of the Bard was based on Raphael's Ezekiel and Parmigianino's Moses:

. . . on a rock, whose haughty brow
Frowns o'er old Conway's foaming flood,
Robed in the sable garb of woe,
With haggard eyes the Poet stood;
(Loose his beard, and hoary hair,
Streamed, like a meteor, to the troubled air;)
And with a master's hand, and prophet's fibre,
Struck the deep sorrows of his lyre.'

Overleaf

THE LAST JUDGMENT 1853
Oil. 198.2 x 324.6
Signed 'J. Martin 1853'
Private Collection

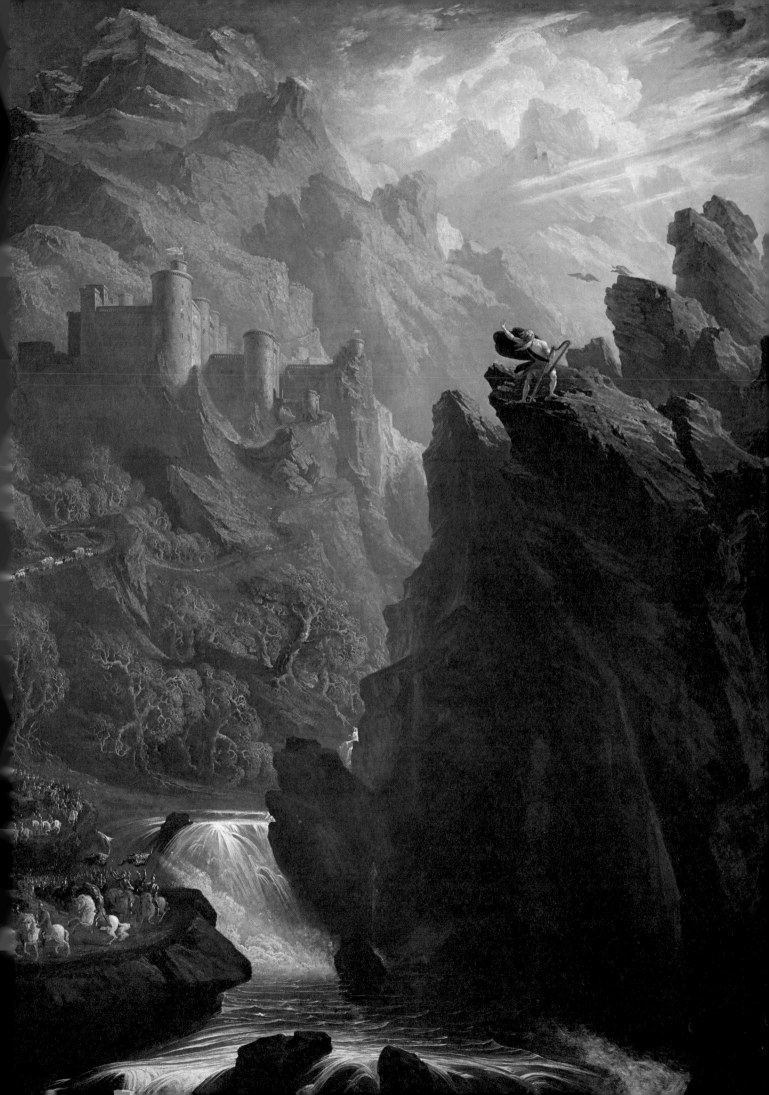

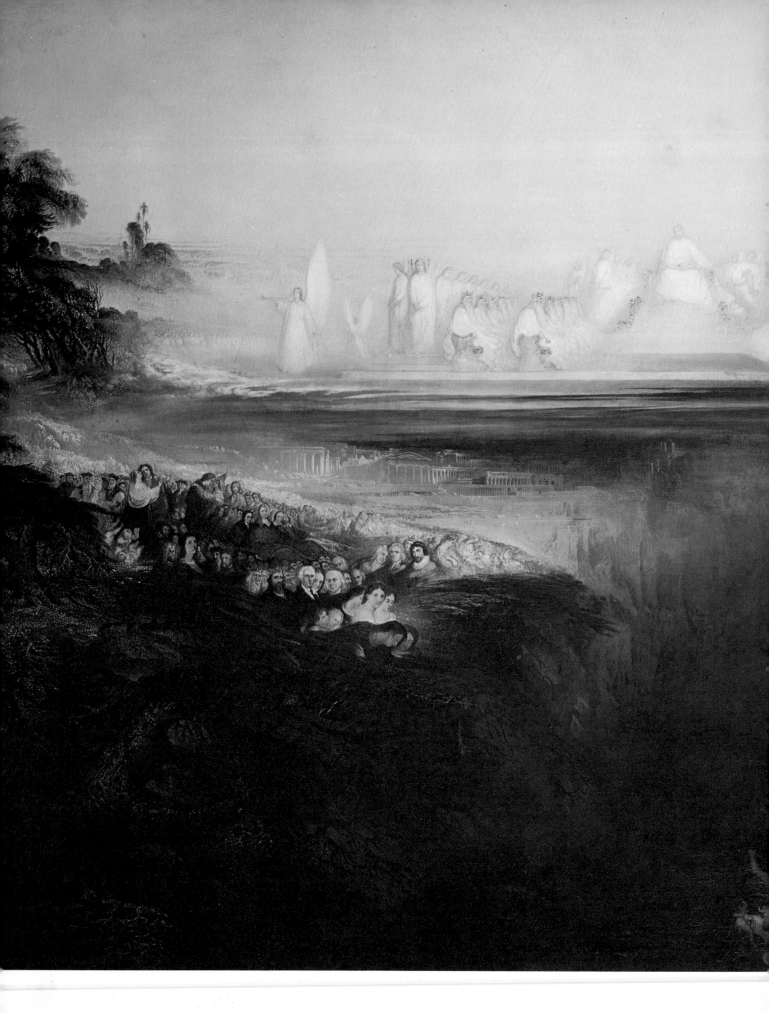

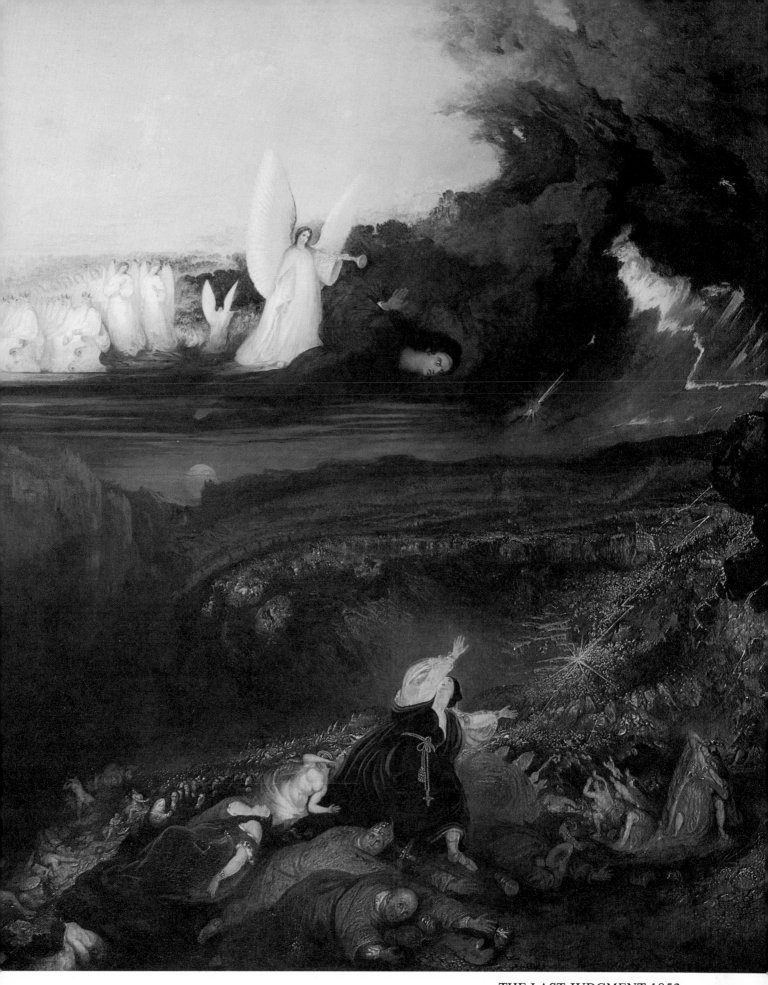

THE LAST JUDGMENT 1853

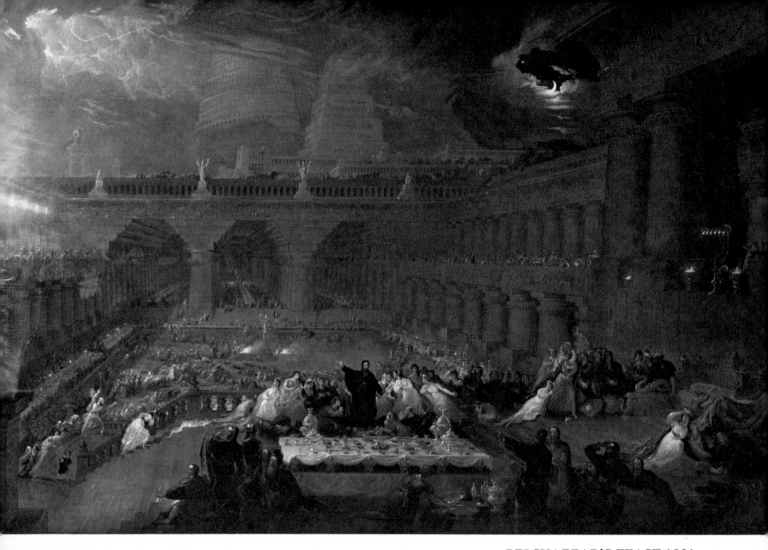

BELSHAZZAR'S FEAST 1821

BELSHAZZAR'S FEAST 1821

Oil. 152.4 x 249
Not inscribed
Ruth F. Wright

Belshazzar's Feast was exhibited at the British Institution in 1821, where it was hung on the line and was awarded the 200 guinea first premium. The reaction it caused among the public and within the London art world was unlike anything seen before or since on account of one painting.

According to Martin, the idea of attempting the subject was given to him by the American painter Washington Allston, who was introduced to him by C. R. Leslie. Allston had almost finished his huge canvas of the same subject (12 x 16 feet) before returning to Boston in 1818. They discussed their respective conceptions of how the scene must have appeared and though Allston disagreed with Martin, he pointed out that his ideas corresponded with those of the Reverend T. S. Hughes a fellow of Emanuel College, Cambridge, who had written an epic poem based on the Biblical story, published 1818. Martin was determined to attempt the subject despite Leslie's warning that if he failed his reputation would be ruined. The painting was finished within a year.

In the letter to Allston quoted above of March 3, 1820, Leslie continued: 'He (Martin) is now employed on your subject of Belshazzar, making it an architectural composition with small figures, the writing on the wall to be about a mile long'. And in letter the following year dated August 8 again to Allston: 'Martin's picture of your subject, Belshazzar, made more noise among the mass of people than any picture that has been exhibited since I have been here. The artists, however and connoisseurs did not like it much' .

To hear this could have been little consolation to Allston, having accepted £10,000 to finish the painting as a commission he tragically took advice of Gilbert Stuart, who told him to change the perspective. From that moment the work never came close to being finished; areas of paint were still wet when Allston died in 1843. The unfinished canvas is in the Detroit Institute of Arts. It is a quirk of fate that much of the fame surrounding these two artists rests on their respective versions of Belshazzar. Martin's was acclaimed in *The European Magazine* as 'a poetical and sublime composition in the grandest style of art' , and the *Magazine of Fine Arts* wrote: 'The most dazzling and extraordinary work is *Belshazzar's Feast,* and one of the most original reproductions of British Art' .

There were of course many criticisms: Ruskin called it 'modern bombast as opposed to old simplicity' , Stothard complained 'The bad drawing hurt my eye; it is disagreeable' . Archdeacon Fisher in a letter to Constable lists it with other London entertainments such as 'the wild beasts, the infant lyre, Bradbury the clown, Braham and *Der Freischütz*, rattlesnakes and the learned pig' . There are contemporary and later accounts too numerous to mention up to and including Sickert: 'my uninfluenced interest certainly went out first of all to Martin's *Belshazzar's Feast*' .

When *Balshazzar* was finished Martin had a four-page quarto prospectus of it printed, the first of many such pamphlets. The principal objects were numbered on an outline engraving and the text consisted of quotations from Daniel and Hughes' poem. The Duke of Buckingham failed to buy the painting for 800 guineas; for it was William Collins, Martin's former employer, who purchased it for an undisclosed price. From Pall Mall, where the exhibition remained open for three extra weeks and the public had to be roped off for security, due to their numbers, the painting was removed to Collins's shop in the Strand where at least another 5 000 people saw it, according to the sales of a 6p pamphlet, *Description of the Picture, Belshazzar's Feast etc.,* undoubtedly by Martin, though signed 'John Bull 1821.' A transparency painted on plate glass, was set into the wall by the shop as an advertisement, though this is not the glass-painting at Syon House, which was done by Hoadley and Oldfield, formerly belonging to the Duke of Northumberland.

There are at least five other versions of *Belshazzar's Feast* of varying sizes and quality, in particular in the Mansion House, Newcastle, and in the collection of Mr. and Mrs. Paul Mellon. Although the original suffered serious damage when the van carrying it was hit by a train when being returned from the opening ceremony of St. George's Hall, Liverpool, the painting has been admirably restored.

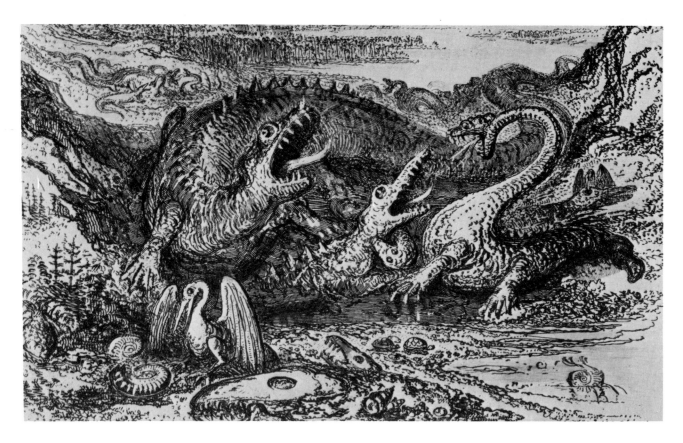

THE COUNTRY OF THE IGUANODON after Martin
Steel engraving. 8.9 x 14.6
Frontispiece to Volume 1 of The Wonders of Geology *by Gideon Mantell, London 1838.*
The Iguanodon was a herbivorous reptile existing in Europe during the early crustaceous period, remains of which had been discovered in Maidstone. Martin, having visited Mantell and seen the remains, was requested by him to paint a reconstruction of the animal and its environment. Mantell was very satisfied with the outcome, and yet when the engraving is compared with Cadmus it is obvious that Martin relied heavily on his original conception of a dragon. The painting was seen by Adam Sedgwick, the Cambridge geologist, and Thomas Hawkins, who had Martin engrave a larger mezzotint for his *The Book of the Great Sea Dragons,* 1840.

CADMUS 1813
Oil. 61 x 90.2
Signed 'J. Martin 1813'
Roy Miles
Cadmus was not exhibited during Martin's lifetime, and until its appearance at Christies in November, 1972, was known only from William Martin's advertisements in his *Lines on the Safety Lamp,* 1827:
 Painted by John Martin the Picture of Cadmus 14 years old
May be seen at Mr. Cail's St. Nicleses Churchyard to be sold for 100 guineas in gold.
That is not one half of its value its very clear to be seen
To those that understand the subject of that part of history keen.
Cadmus was the founder of the city of Thebes and brother of Pheonix, Cilix and Europa.

THE EXPULSION OF ADAM AND EVE FROM PARADISE
Oil. 78.7 x 109.9
Not inscribed
Private Collection
A large version of the same subject was exhibited in the British Institution in 1813. Plate 24 of his *Paradise Lost* illustrations repeats the design but in reverse, and a drawing in Philadelphia dated 1843 is of the same subject but a different composition.

39

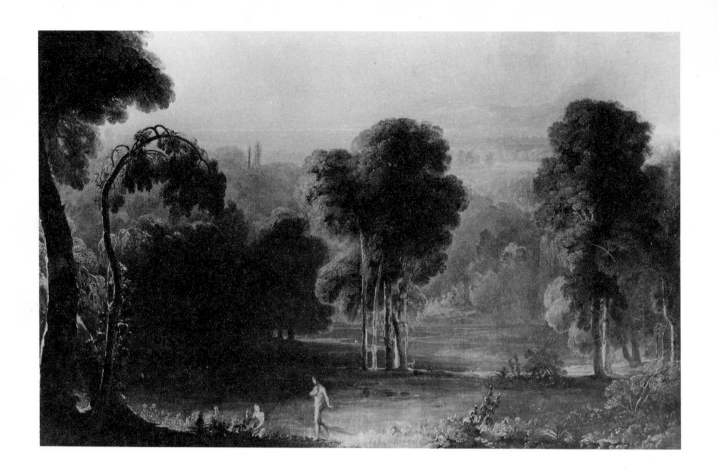

ADAM'S FIRST SIGHT OF EVE 1812
Oil. 70.2 x 105.7
Signed 'J. Martin 1812'
Glasgow Art Gallery
'Nature herself, though pure of sinful thought
Wrought on her so, that seeing me, she turned.'
Milton
Exhibited at the Royal Academy in 1813, this and *The Bard* were the only paintings Martin exhibited at the Royal Academy which were not relegated to the Ante-room. It is one of the few Miltonic subjects which Martin had painted before his commission to illustrate *Paradise Lost*.

SADAK IN SEARCH OF THE WATERS OF OBLIVION 1812
Oil. 76.2 x 62.4
Signed 'J. Martin 1812'
Southampton Art Gallery
This is a smaller version of Martin's first exhibited subject painting, which was hung in the Ante-room of the Royal Academy in 1812. The present whereabouts of the original is unknown, but in 1919 and until 1933 at the latest a 'large' Sadak which might have been the original was in the possession of Thomas Sutton of Eastbourne. Another later version is in the Boston Museum of Fine Art.
A steel engraving of the Southampton version by E. J. Roberts was published in *The Keepsake* of 1828, and Alfred Martin's engraving of the original, which shows some small variations, was published in 1841. The story is taken from *Tales of the Genii* by James Ridley. It was first published in book form in 1762 in translation from Persian by Sir Charles Morell, Ambassador to the Great Mogul. This particular story tells of Sadak, a learned and wealthy young nobleman, who, having become disillusioned with life, desired only forgetfulness. The Deev Alfakir promised to fulfil his wish and sent him to a remote and rocky island where he found the Waters of Oblivion rushing over a steep precipice. The Deev appeared and bade him drink, but when Sadak refused, the Deev hurled him into the waters which closed over him.

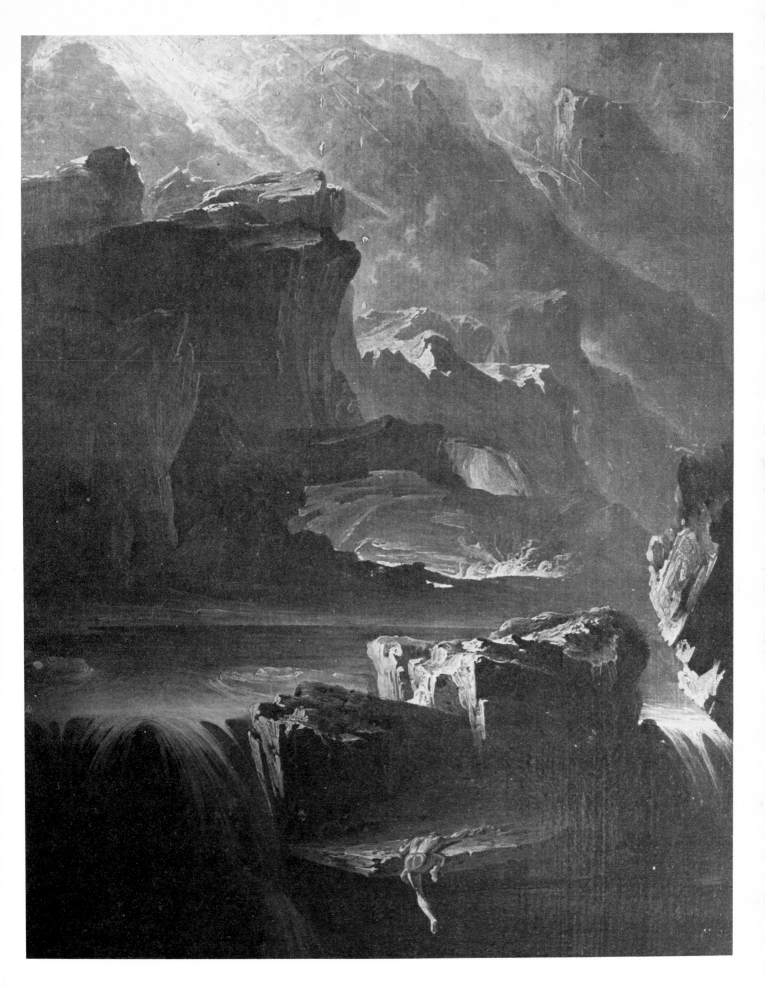

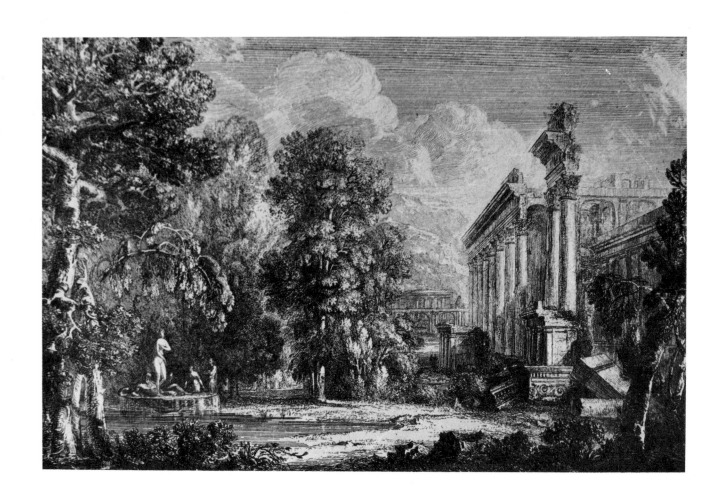

CLASSICAL RUINS
Etching. 13.5 x 20.6
Signed 'Jn. Martin'
Victoria and Albert Museum
Photograph by courtesy of Richard Green.

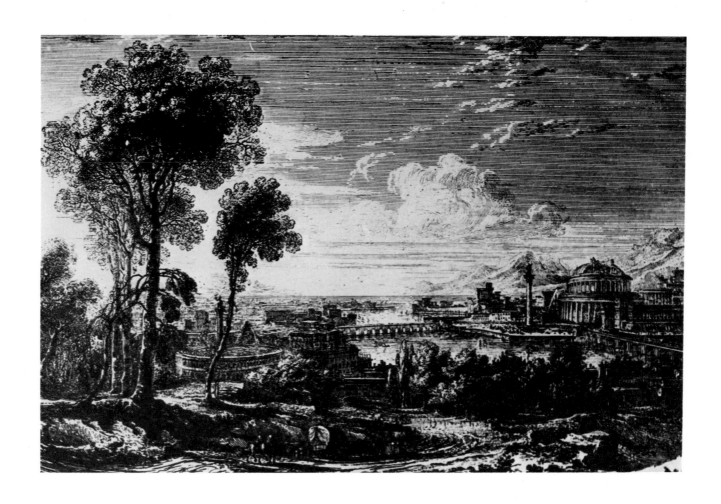

CLASSICAL CITY 1816
Etching. 14 x 20.6
Signed 'J. Martin 1816'
Victoria and Albert Museum
Photograph by courtesy of Richard Green.
These are the earliest of Martin's prints about which there is no information. Martin must have been etching and engraving for some time before these were published to have attained this fluency and to be given the commission for *Characters of Trees,* published the following year.

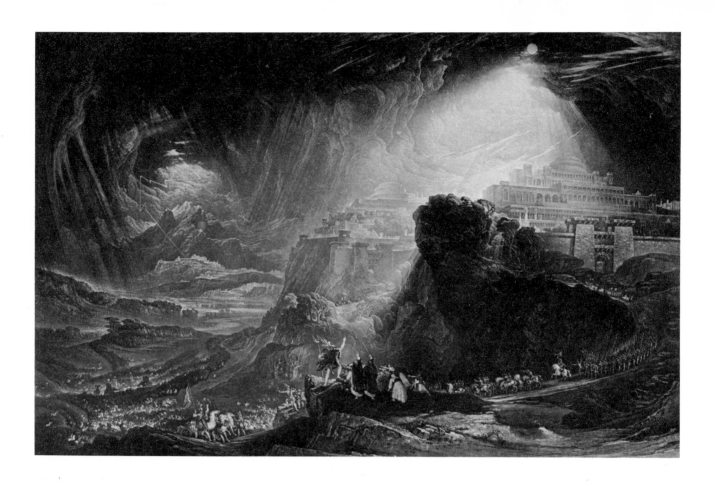

JOSHUA COMMANDING THE SUN TO STAND STILL UPON GIDEON 1827
Mezzotint. 53.3 x 76.2
Lettered with title, dedication to Prince Leopold of Saxe-Coburg and painted & engraved by John Martin. Published May 9, 1827, by Mr. Martin, 30 Allsop Buildings, New Road. Proof printed by S. H. Hawkins.

In 1816 Prince Leopold and Princess Charlotte had appointed Martin their Historical Landscape Painter. To show his appreciation, Martin had commissioned Charles Turner (the engraver of the first 20 plates in J. M. W. Turner's *Liber Studiorum*) to make a large engraving of his painting. Turner never got very far, and at some expense to Martin, the contract was cancelled and the unfinished copper plate destroyed. Martin engraved a new steel plate in four weeks, dedicating it to Prince Leopold as promised. The plate remained in Martin's possession until his death and appeared in the Lindsey House sale.

Bernard Barton's *A New Year's Eve,* 1828, included 'To John Martin, on his magnificent print of Joshua', an extract from which runs:

> Light and shadow, death and doom,
> Glory's brightness, horror's gloom,
> Rocky heights of awful form,
> Grandeur of the bursting storm:
> Vistas of unbounded space,
> Architecture's richest grace,
> Lurid clouds by lightnings riven,
> Conflict fierce on earth, in heaven!
>
> Such the marvels proud and high
> Brought out by thy mastery .

The only alterations made in the mezzotint to the original composition were the round tower's gate which became square, and the pyramid behind in place of which he placed a long flat-roofed building.

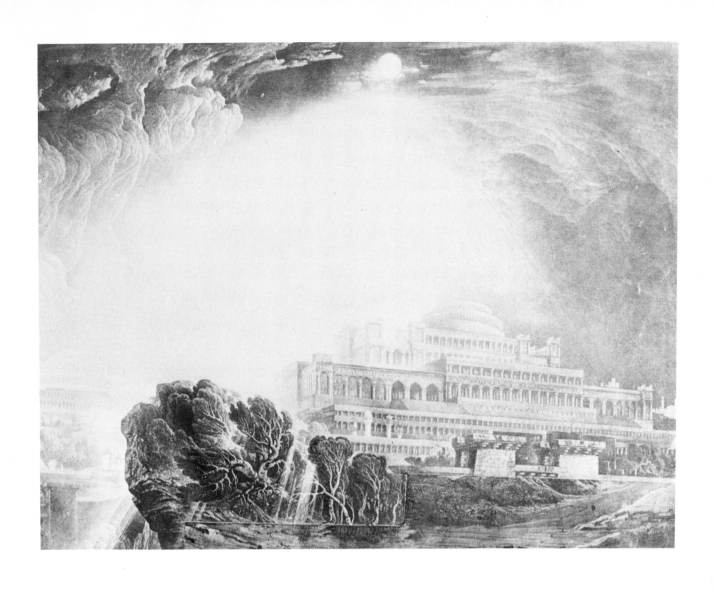

JOSHUA COMMANDING THE SUN TO STAND STILL UPON GIDEON
A detail of the city in the mezzotint taken from a page in Martin's album.

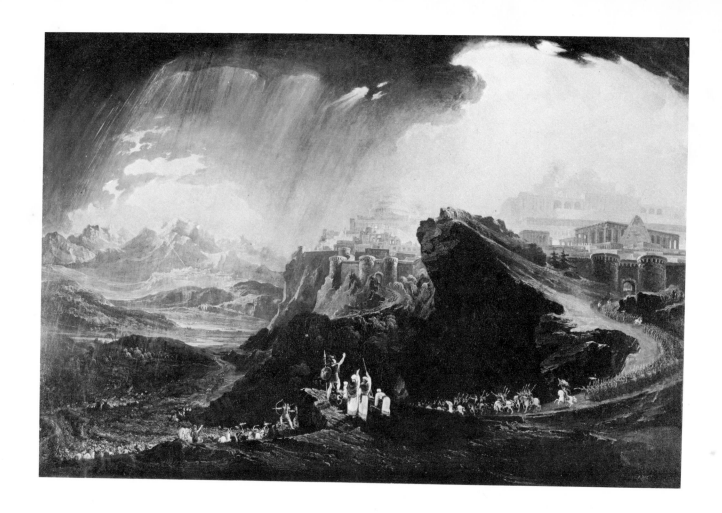

JOSHUA COMMANDING THE SUN TO STAND STILL UPON GIDEON
Oil. 149.9 x 231.1
Signed 'J. Martin'
United Grand Lodge of England

Although hidden away in the Ante-room of the Royal Academy in 1816, remaining unsold at the end of the exhibition, Anderson noted that 'This was a mighty triumph for Martin. He had appeared in 1812 and had won upon the public, but this acquired immense applause for him.' It was re-exhibited at the British Institute the following year and was awarded the second premium of £100. R. J. Lane published a lithograph of it in 1827, four months before Martin's own mezzotint eventually appeared. An equal size copy of the original painting was last seen in the Drake sale at the Baltic Exchange in 1928, modified according to the mezzotint. As well as a small oil version in a private collection there are two sepias, both identical with the original, one of which is squared-off.

There is, in the possession of Edmund Blunden, an oil sketch of *Joshua,* which Martin had given to his landlady, one Mrs. Nicholson, when he could not pay for his lodging.

MOSES AT THE RED SEA
Watercolour heightened with chinese white. 5.4 x 7
Victoria and Albert Museum
This watercolour, illustrating an episode from Exodus xiv, is related to Martin's studies for *Joshua*.

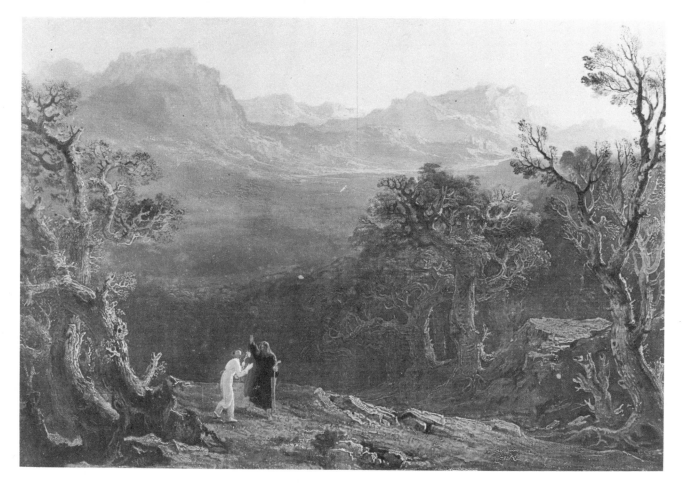

EDWIN AND ANGELINA 1816
Oil. 20.2 x 43.5
Signed 'John Martin 1816'
Private Collection
Exhibited at the British Institution in 1817 with the following quotation from Goldsmith's ballad of the same title generally known as *The Hermit*:
Turn, gentle hermit of the vale,
And guide my lonely way,
To where yon taper cheers the vale
With hospitable ray .
The ballad was first published in *The Vicar of Wakefield* in 1766. Martin exhibited a large oil, *Goldsmith's Hermit*, at the British Institution in 1843, its present whereabouts unknown.

A SOUTHERN BAY 1817
Watercolour. 19.4 x 27
Signed 'J. Martin 1817'
Private Collection
Like all Martin's so-called landscape classical compositions this is a purely imaginative study, there being no evidence to suggest that Martin ever left Great Britain.

LANDSCAPE CLASSICAL COMPOSITION
Sepia. 18.5 x 29.8
Not inscribed
Laing Art Gallery
It is probable that this is an example of the kind of sketch which served as a study for the architecture in for example, *The Last Judgment.*

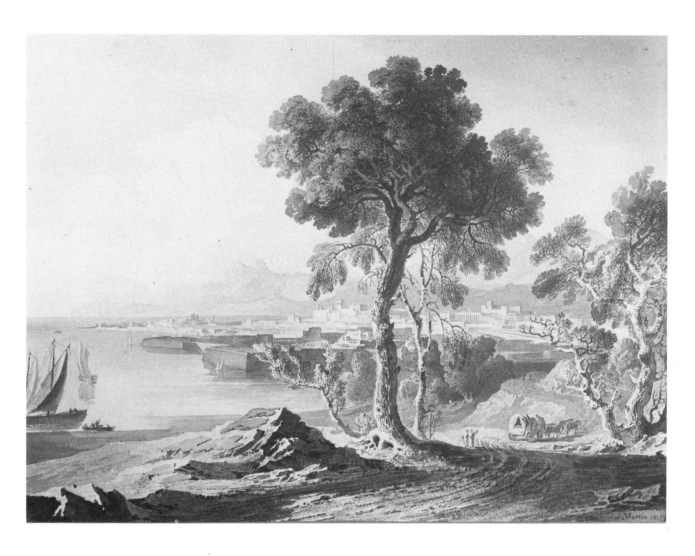

49

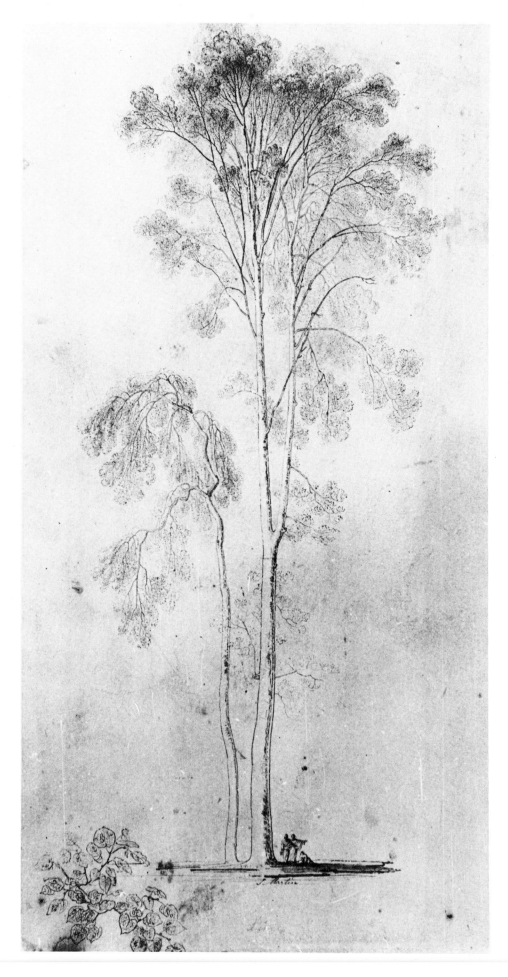

LIME TREE
Indian ink and body colour. 43.3 x 15.4
Witt Collection
One of two studies for *Characters of Trees* in the Witt Collection, the other being of a Pine. A third study of a Cedar (not published as an etching) appeared at Spinks in November 1948. Each of the drawings includes a sketch for the details in the last plate of the book.

Overleaf

THE FALL OF BABYLON 1831
Mezzotint. 53.3 x 76.2
British Museum
'*London: Painted, Engraved and Published by John Martin, 30 Allsop Terrace, New Road, October 1831.*'
Martin's oil painting of this subject was exhibited at the British Institution in 1819, its size (framed) given as 76 x 112 inches. It was sold to Henry Hope for 400 guineas, substantially improving Martin's finances at this time. An outline engraving with the principal subjects numbered and described appeared in the catalogue of Martin's one-man exhibition at the Egyptian Hall in 1822, to which Hope had loaned the painting. The main sources cited were Herodotus and Diodorus Siculius However, among the books which Martin must have seen at this time, was C. J. Rich's *Memoirs of the Ruins of Babylon* (1816) wherein is given this description of the Temple of Belus: 'Its form was pyramidical, composed of eight receding stages. The tower was solid (with the exception of the small chambers or holy cells) and it was cased with furnace-baked bricks'. There is no historical description of the Tower of Babel, which appears in all of the Assyrian pictures, which probably accounts for Martin's rare lack of detail in its depiction. Other identified edifices are: 'The Palace of Semiramis, four miles in circumference (left centre); 'The Palace built by Nebuchadnezzar, eight miles in circumference, on which were the Hanging Gardens' (right foreground); and 'The Bridge built by Nitocris:- observe the joining of the stones, which have the strength of an Arch without being one' (centre below the Tower of Babel). In the descriptive pamphlet to *Joshua,* Martin pointed out: 'Neither in holy scripture, nor in Herodotus does the word ARCH appear, no signs of which are to be found in all the extensive ruins of Babylon.'
William Beckford wrote to Chevalier Franchi, 5 February, 1819: 'I have been three times running to the exhibition in Pall Mall to admire *The Capture of Babylon* by Martin. He adds the greatest distinction to contemporary art, Oh, what a sublime thing.'
C. R. Leslie writes the following day to Washington Allston: [At the British Gallery] 'though I mention it last, certainly very far from least, a magnificent picture of *The Fall of Babylon,* by Martin, which I think, even surpasses his *Joshua,* I need say no more, it attracts admiration, and Sir John Leicester [later Lord de Tabley] has been to see him on the strength of it. I hope it will benefit his purse.'

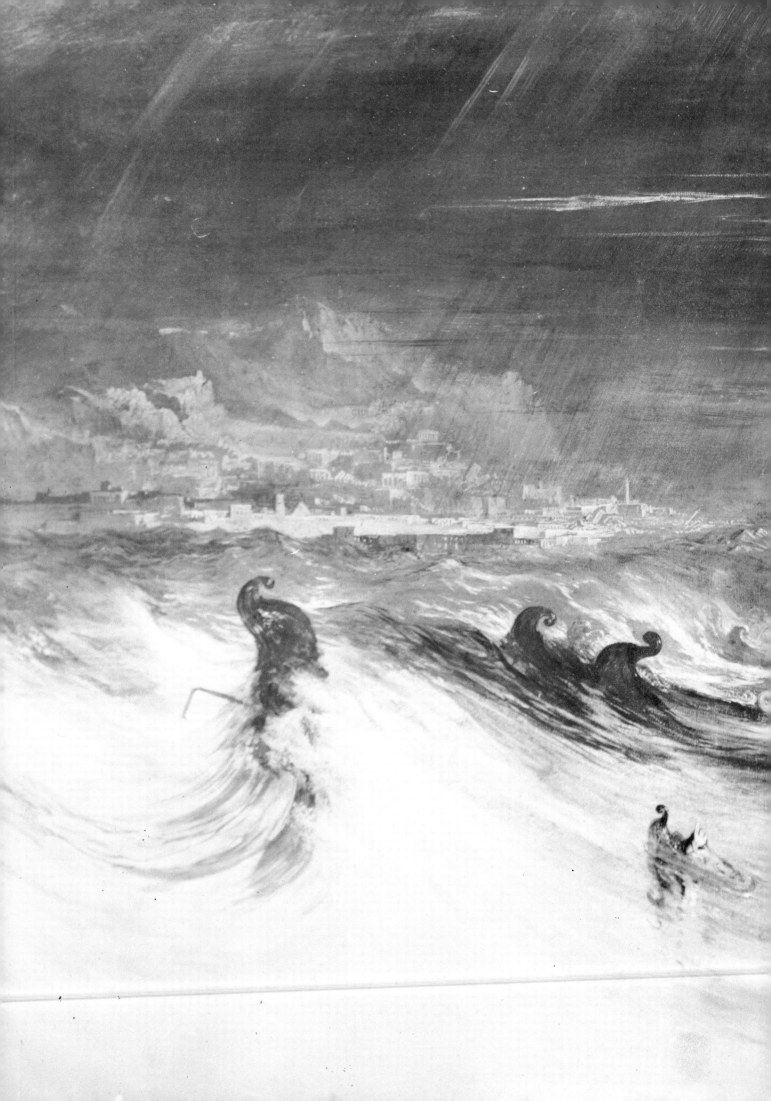

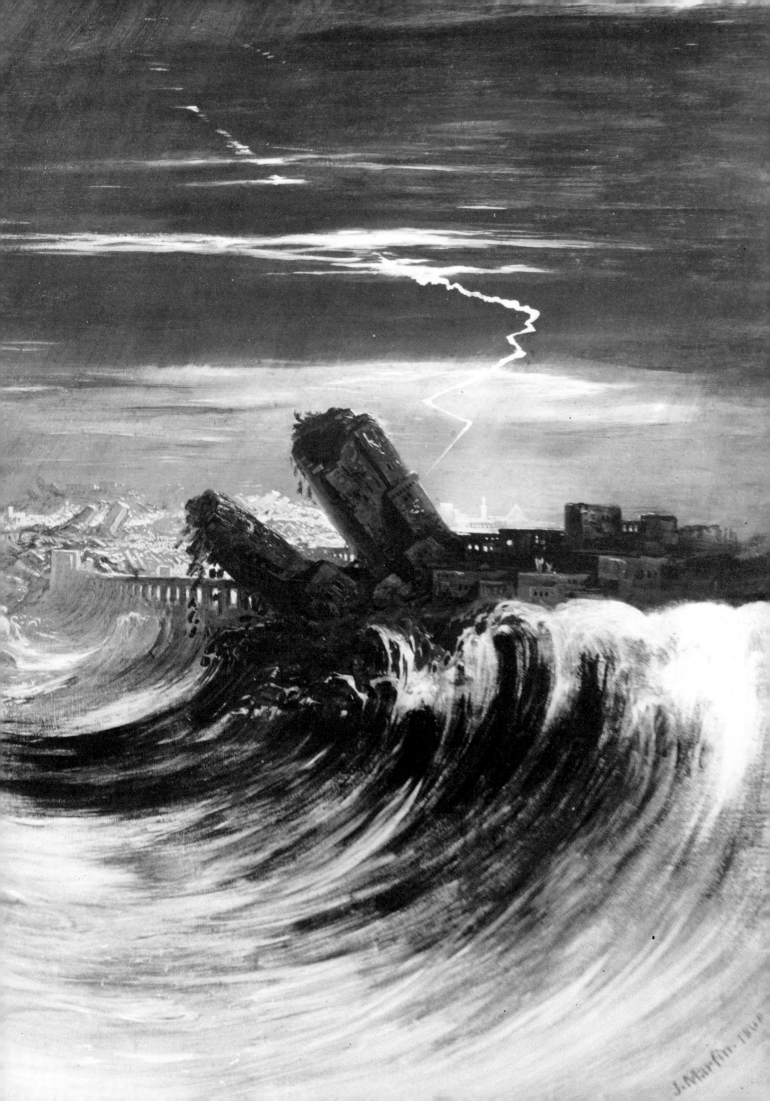

MARTIN'S ALBUM
Mezzotints and engravings. Size of Volume 43 x 43
Victoria and Albert Museum
The volume was compiled by Martin and contains eighty-four cuttings from proof impressions of his mezzotints and three engravings after his designs, and includes six complete engravings from the *Illustrations to the Bible*. The pages are inscribed throughout, and the details especially of landscape and architecture show that Martin's design sense was far greater than had been attributed to him previously. The page illustrated shows details from Glen Lynden, the Fall of the Rebel Angels, Adam Reproving Eve, Satan Tempting Eve, and the Ascent of Elijah.

ELM TREE 1817
Etching. 42.8 x 29.8
Signed 'J. Martin'
Victoria and Albert Museum
'A plate from *Characters of Trees,* in a series of seven plates, drawn and etched by F. Martin, landscape painter to H.R.H. the Princess Charlotte and H.S.H. the Prince of Saxe-Coburg' published by Ackermann in 1817. The 'F. Martin' is due to the misreading of the 'J' in Martin's signature in the plates. Six trees were illustrated: Ash, Elm, Horse-chestnut, Oak, Lime, Pine, the seventh being a twig and foliage of each tree.
Martin had managed to sell Ackermann some drawings when he first arrived in London, but because he was forced to greatly reduce the price Martin swore he would never deal with him again. However, as fate would have it, Ackermann became his first publisher with this book.

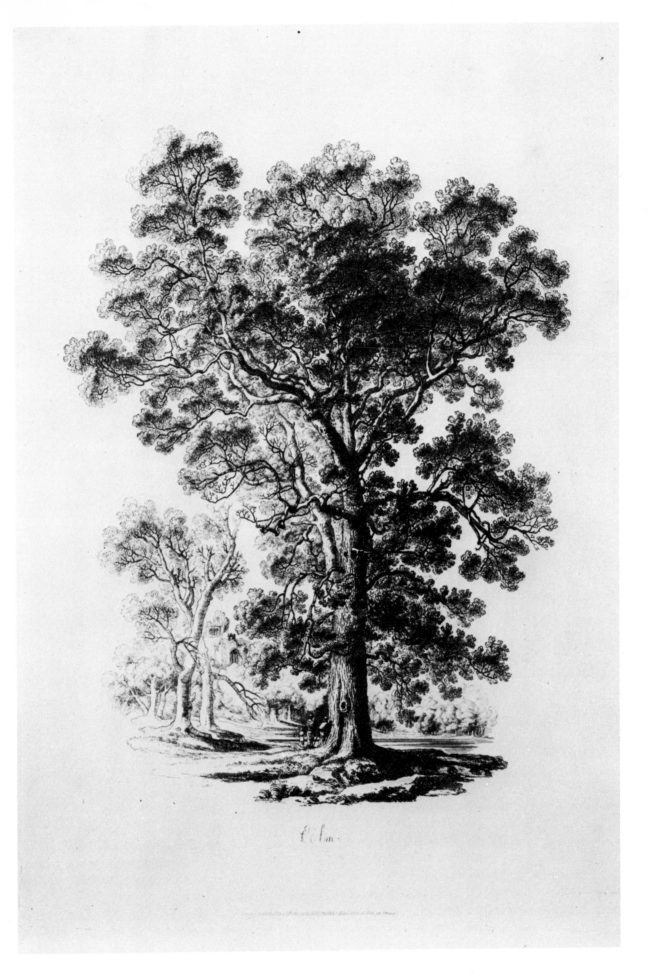

Elm.

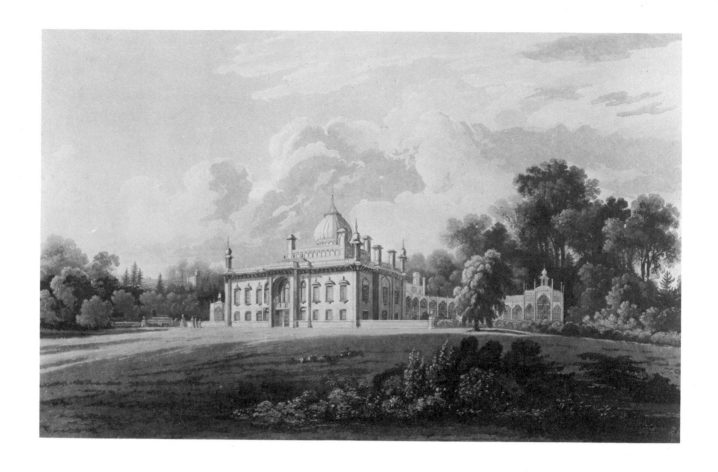

SEZINCOT HOUSE - East View of Mansion House
Aquatint. 33.6 x 46.3
British Museum

The fourth plate in a series of ten drawn and etched by Martin and engraved by F. C. Lewis, 'Engraver to the late Princess Charlotte'. The plates are undated but they were probably published in 1819. The etchings and aquatints are bound into a single volume in the British Museum print room.

Sir Charles Cockerell started to remodel his house in Gloucestershire around 1805, employing his architect brother, Samuel Pepys Cockerell, and using the Mausoleum of Hyder Ali Khan at Laulbaug as a model. S. P. Cockerell was assisted by Thomas Daniell whose knowledge of Indian architecture was unrivalled. Martin probably made the etchings in 1817 or 1818, during which time he would have had access to Sir Charles' large collection of Daniell's topographical views in the East.

As can be seen in the plates of *Characters of Trees,* Martin acquired great facility in producing picturesque grandeur in straightforward views by changes of scale and perspective, emphasized in this example by the minute cattle in the foreground and the figures in front of the house.

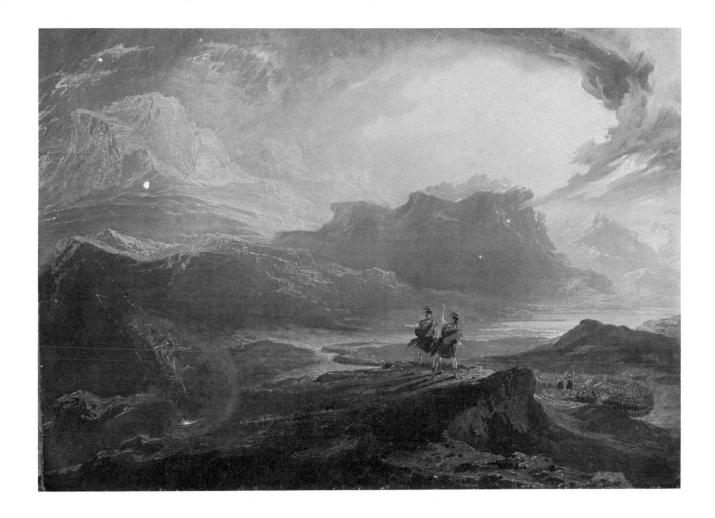

MACBETH
Oil. 51 x 72
Not inscribed
National Gallery of Scotland.
Martin exhibited a large painting of *Macbeth* (68 x 96 ins. framed) at the British Institution in 1820 with the following caption in the catalogue:
Macbeth, upon his return from the Highlands, after the defeat of Macdonald, meets the Weird Sisters on the blasted heath before sunset.
Macbeth, Stay you imperfect speakers, tell me more.
Banquo, Whither are they vanished?
In 1822, it was shown at the first exhibition of the Northumbrian Institution, the only painting of Martin's to be exhibited in Newcastle until the *Judgment* pictures just before his death. The painting was still in his studio in 1831 where it was seen by Sir Walter Scott. According to Leopold 'One feature of the visit was the special interest he was pleased to take in one of my father's early works, one of the few still in his possession, the picture of *Macbeth,* expressing great regret at his inability to purchase it, as he should like to place it on the wall at Abbotsford. My father's like inability to offer it as a gift was a great regret'
An earlier mention of the painting is in a letter from C. R. Leslie to Allston, of March 3, 1820: 'Martin has painted a picture of Macbeth and Banquo meeting the witches on the blasted heath; it is as usual, tremendously grand.'

The only Shakespearian subject painted by Martin, there are three versions besides the lost original, at Stratford Shakespeare Memorial Theatre, in Philadelphia, and Edinburgh; Martin's depiction of this popular Romantic scene is an early example of kilted Scots in Shakespearian illustration.

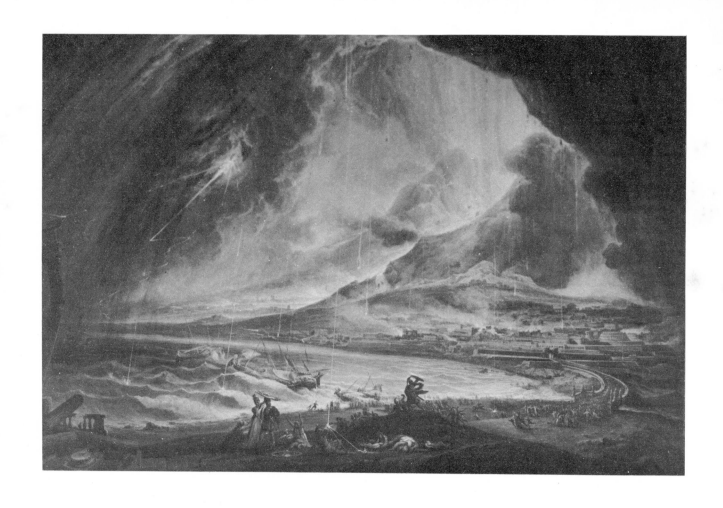

THE DESTRUCTION OF HERCULANEUM AND POMPEII
Watercolour. Approx. 64 x 82
Not inscribed
Ruth F. Wright
This watercolour is superficially quite close to the original canvas, differing to a greater extent in the foreground figures. It is known by the title of *Tongues of Fire,* and could conceivably have been a study for the oil painting.

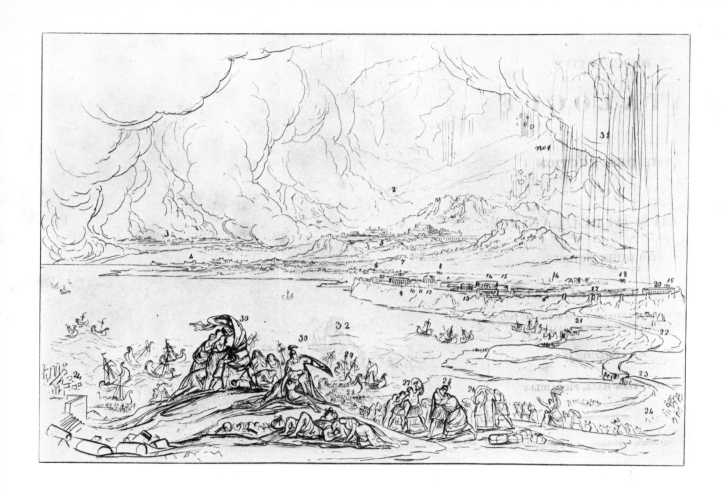

THE DESTRUCTION OF HERCULANEUM AND POMPEII 1821

Engraving. 20 x 26
Signed 'J. Martin 1821'

Sir William Gell and J. P. Gandy had published in 1817 and 1819 *Pompeiana: the Topography, Edifices, and Ornaments of Pompeii.* The subject remained topical enough for Martin to select it for his next large painting, commissioned by the Duke of Buckingham. It was exhibited in Martin's one man show at the Egyptian Hall in 1822, along with another 24 paintings, including all his major works to date, excepting *Belshazzar.* This outline engraving of the oil painting was the frontispiece of the 32-page *Descriptive Catalogue* of the exhibition, the text of which was mainly taken from *Pompeiana,* but also included a quotation from Edwin Atherstone's *The Last Days of Herculaneum* (1821). The painting itself was not a particular success, Martin himself feeling not quite up to the task he had set himself: 'the artist who has ventured upon the arduous undertaking of attempting to represent this scene of desolation has trusted more to the interest inseparable from the subject than to his own powers. Although he has sedulously consulted every source of information within his reach, which might enable him to complete his task with strict attention to historical truth. . . he is fully sensible that the attempt which he now submits to inspection must require the indulgence of a candid and liberal public.' After the exhibition, the picture went to Stowe, where it remained until the sale of 1848. It was acquired by the National Gallery in 1869, and transferred to the Tate in 1918, where ten years later it was severely damaged in the Millbank flood and at present remains unrestored.

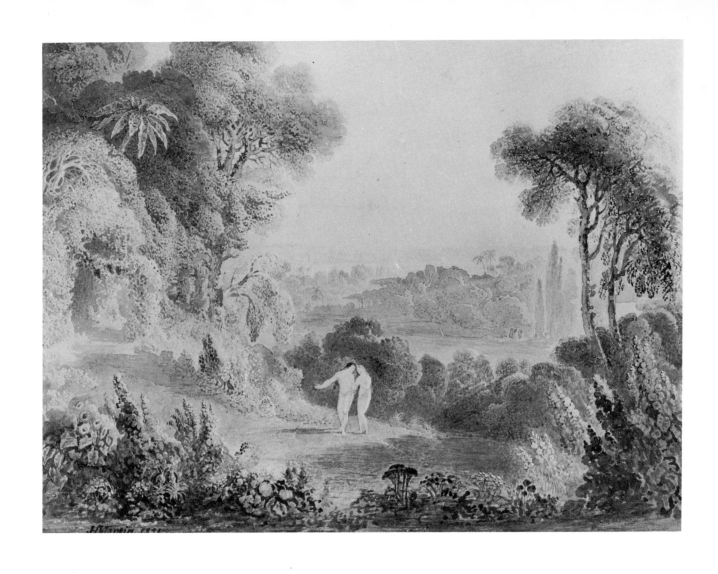

THE GARDEN OF EDEN 1821
Watercolour. 19.4 x 26.3
Signed 'J. Martin 1821'
Tate Gallery

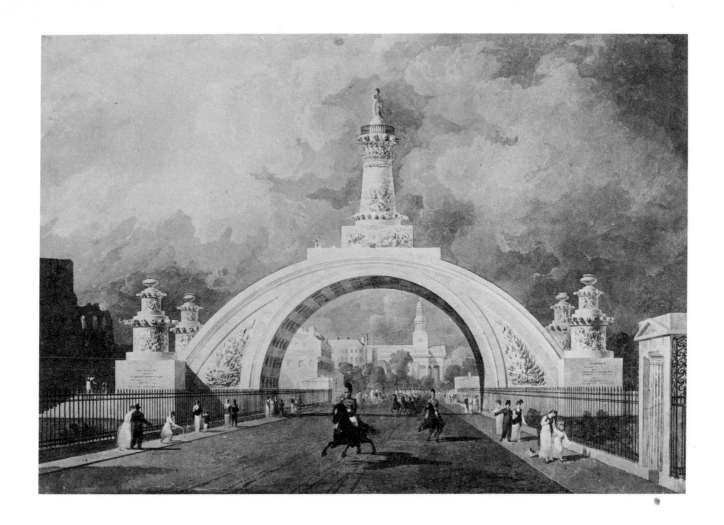

VIEW OF A DESIGN FOR A NATIONAL MONUMENT TO COMMEMORATE THE BATTLE OF
WATERLOO, ADAPTED TO THE NORTH END OF PORTLAND PLACE
Sepia. 34.6 x 54
Signed 'J. Martin 1820'
British Museum
One of the two views in the British Museum which were exhibited at the Royal Academy in 1820.
Another view similar to this is illustrated in Pendered (formerly in the collection of Colonel Bonomi),
'Design for the Thames Embankment' . This is obviously mistitled as the top of Park Crescent and one
of Nash's little lodges can clearly be seen. The view looks west along the Marylebone Road. In the
distance can be seen the portico of the Parish Church St. Mary where Martin was married, and approxi-
mately opposite which he lived from 1818. The monumentality of Martin's designs owes something to
earlier designs of the French visionary architects like Boullee, Ledoux, and Vaudoyer - the last-named
publishing designs in 1806. This same influence can be seen in some of the plates to *Paradise Lost.*

61

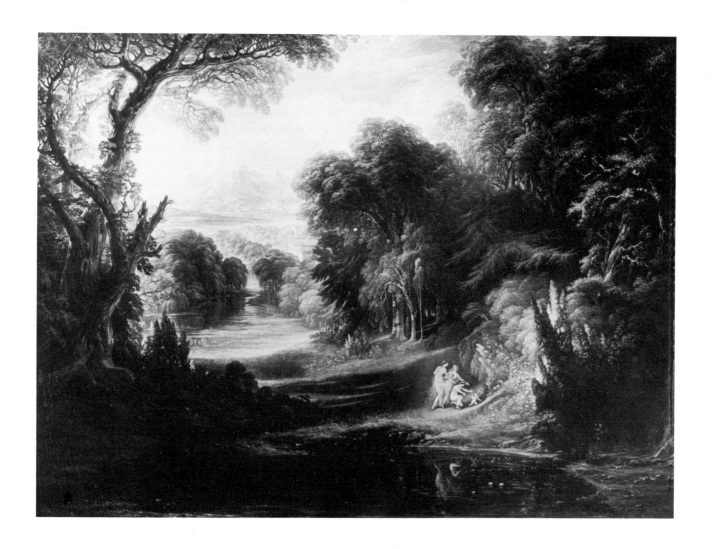

THE PAPHIAN BOWER 1826 after Martin by G.H. Phillips
Mezzotint. 42.5 x 58.7
Photograph courtesy of Richard Green
Published by Martin and F. G. Moon

The original painting was exhibited in the Royal Academy in 1823. According to the Redgraves it was re-exhibited at the British Institution 'a part having been pasted over, and a new subject inserted in the centre of the canvas' under a new title *The Graces Culling Poise,* but no mention of a work by Martin fitting this title or description appears in the British Institution catalogues. Its whereabouts are now unknown, though it was probably the picture in the Naylor-Leyland Sale in 1923, *A Landscape with Three Nymphs Discovering Cupid Asleep.*

Anderdon notes in the catalogues at the Royal Academy that 'this picture partakes of all Mr. Martin's usual peculiarities, and has, as far as outrageous things can have, some extraordinary merits: that there is "genius" about the compositions of the artist we do not mean to dispute: but we shall contend that it is genius misplaced. Mr. Martin's talent is wholly scenic and not natural . . . in an Academy, where the artists profess to copy nature, it cannot be too severely censured. The ill-judged praise bestowed on this florid style by the ignorant has already done serious injury to the rising artist.' He goes on to congratulate the Hanging Committee for hiding the picture away (in the Ante-room) 'where its gaudy effects cannot injure superior productions.' As for the figures, they are 'certainly the most graceless giantesses we ever saw, with long legs and little bodies. The arch urchin is infant decrepitude personified,' and so on, ending with 'it is altogether a most preposterous extravaganza'.

There is also a small steel engraving after Martin by George B. Ellis in the *Atlantic Souvenir* (Philadephia 1832), titled *The Bowers of Paphos* .

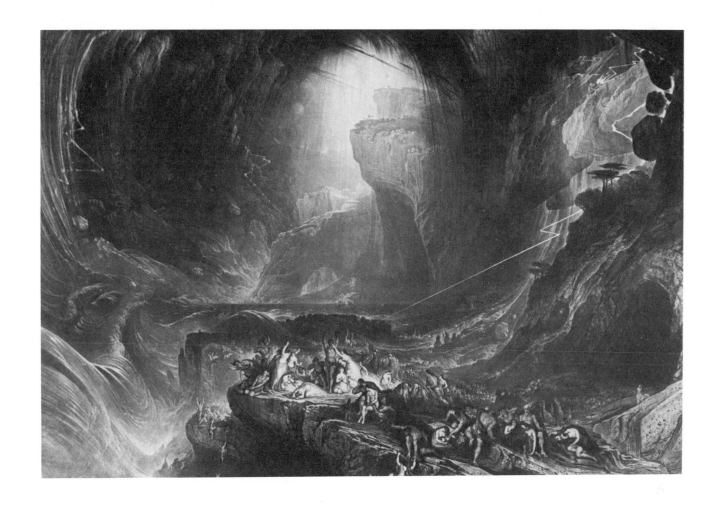

THE DELUGE 1828
Mezzotint. 53.3 x 76.2
Victoria and Albert Museum
The print was dedicated to 'His Imperial Majesty Nicholas the First, Emperor and Autocrator of all the Russians, and etc., as a humble tribute to the Artist's gratitude for the high honour His Imperial Majesty has been graciously pleased to confer upon him'. The date of the Czar's visit to Martin's studio is unknown, but he presented Martin with a diamond ring and gold medal on the occasion. The design of the print was based on Martin's painting exhibited at the British Institution in 1826 (whereabouts unknown). Not long after the publication of the print, Martin produced an eight-page descriptive pamphlet in which he states that he had made 'improvements in the composition giving it a degree of originality which could not attach to a mere copy of any picture'. As well as the outline engraving and text, there were ten stanzas from a poem by Bernard Barton, *Recollections of Mr. Martin's Print of the Déluge,* in the same vein as the poet's previous lines on the *Joshua* print.

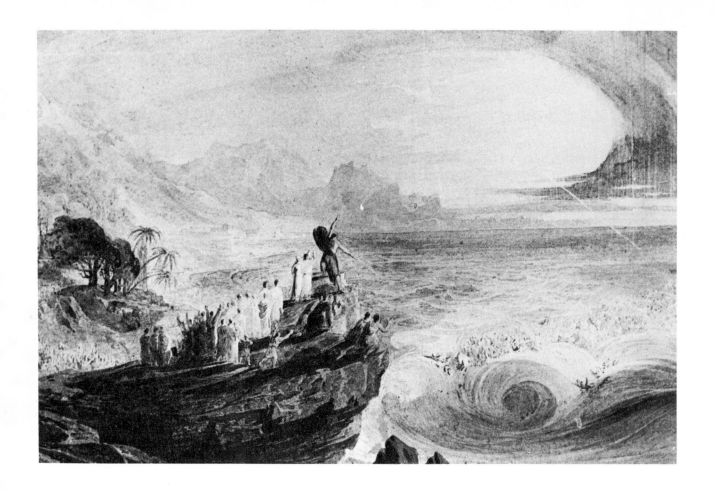

THE DESTRUCTION OF THE EGYPTIANS
Watercolour. 15.5 x 20.6
Signed 'J. Martin'
Victoria and Albert Museum

This and a companion picture of *Moses Dividing the Red Sea* (Victoria and Albert Museum) have been dated 1832 by Balston. They are possibly studies for Martin's *Illustrations of the Bible* which were started in 1831.

THE REBELLION OF KORAH 1833
Wash. 8.5 x 14
Signed 'J. M. 1833'
Victoria and Albert Museum

The subject, which was engraved for the Westall and Martin Bible illustrations, 1837, is taken from Number 16. Korah attempted with others to arrogate the priestly office of offering incense and was struck dead by lightning.

QUEEN ESTHER after Martin by Alfred Martin
Mezzotint. 30.2 x 40.5
Victoria and Albert Museum

In 1831 Martin exhibited only two paintings, *Queen Esther* and *Marcus Curtius,* both watercolours, at the British Artists. *Queen Esther,* engraved by E. Finden, was published in *Forget Me Not* for that year. Alfred Martin's mezzotint, though undated, is according to Balston an early work.

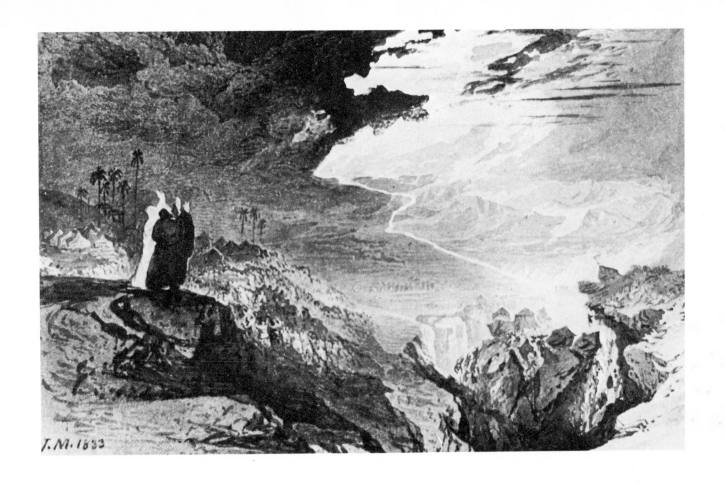

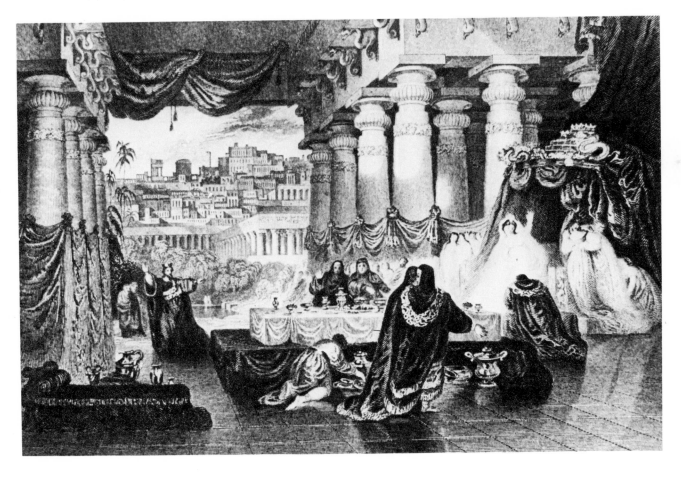

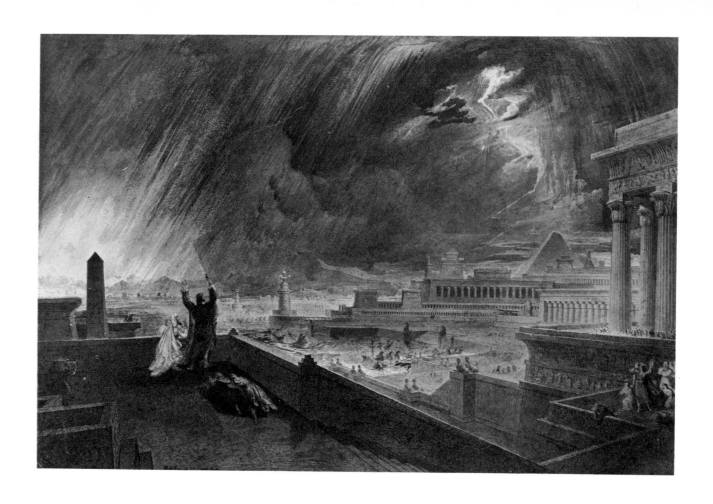

THE SEVENTH PLAGUE OF EGYPT 1833
Watercolour. 23.5 x 36.2
Signed 'J. Martin 1833'
Private Collection
The oil painting signed and dated 1823 (Boston Museum of Fine Arts) was exhibited at the inaugural exhibition of the Society of British Artists, with a quotation from Exodus ix, xxii-xxiv, xxvi, and the following year at the British Institution. The subject was done in mezzotint by Martin for the 1838 *Illustrations of the Bible,* and engraved by C. Gray for the Westall and Martin *Bible.* Although painted a decade later than the original, the watercolour repeats the design almost exactly. In 1800, Turner exhibited his mistitled *The Fifth Plague,* which was engraved in the *Liber Studiorum.* The two versions provide a useful comparison of the conceptions of the two artists.

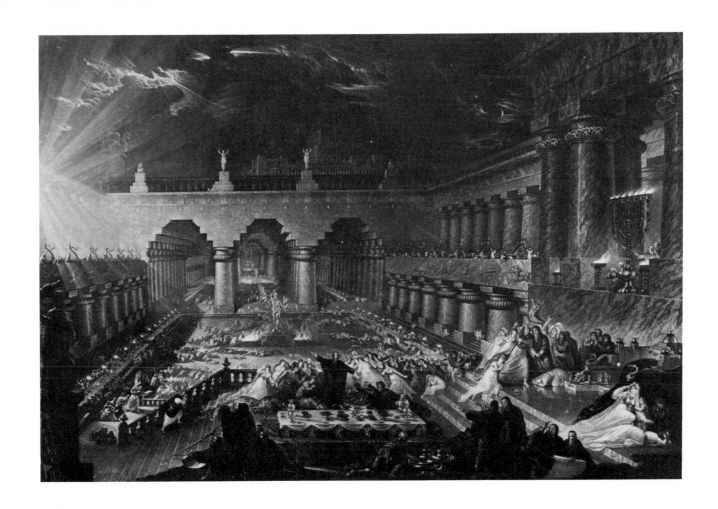

BELSHAZZAR'S FEAST 1832

Mezzotint. 53.3 x 76.2

Victoria and Albert Museum

Martin first published a mezzotint of *Belshazzar's Feast* in 1826, dedicated to George IV. He had started to engrave a copper plate but the work was delayed by the commission for the illustrations to *Paradise Lost*. He scrapped the copper plate substituting it for the longer wearing steel, and was assisted by Thomas Lupton who had been awarded the Isis Medal at the Society of Arts for his soft steel plate in 1822. The new plate was announced in *The Literary Gazette* on February 10, 1826, and advertised as ready for delivery on June 10, proofs costing 5 guineas, prints £2.10. It was printed and published by Martin himself, as were the following large plates. The success of the prints is shown by their prices in 1829, when unletter proofs were now 14 guineas, prints 3½. By 1832 the first plate was worn out, and due to a continuing demand, Martin engraved a second plate, the only difference being that the patterned border and titling were now discarded and the dedication transferred to the new king, William IV.

As well as the two large plates, Martin engraved a small mezzotint for his *Illustrations of the Bible* (1835). Other engravings were done by Horsburgh for Blackie's *Imperial Bible,* by Powis for the Westall and Martin Bible illustrations and by William Martin, who proposed a different conception for the appearance of the writing on the wall. The original copper plate was in the Lindsey House sale after Martin's death.

ALEXANDER AND DIOGENES 1827

Watercolour. 25 x 31.5

Not inscribed

Victoria and Albert Museum

One of the new pictures in Martin's exhibition at the Egyptian Hall in 1822 was a small oil reproduced in Grant's *Old English Landscape Painters in Oil,* called *Diogenes visited by Alexander.*

Two small engravings by E. Finden, after similar versions of the subject were published in two rival annuals in 1827, the *Literary Souvenir* and *Friendship's Offering,* the latter apparently being the pirated 'after an inferior sketch'. In the same *Literary Souvenir,* an imaginary conversation was recorded between James Hogg, the Ettrick Shepherd and his friend 'Christopher North' (Professor Wilson), one of the several notices by them of Martin's work, including *The Paphian Bower, The Deluge* and *Joshua.* North asks the Shepherd: 'didna ye notice the prent o'Martin's *Alexander and Diogenes?* That Martin to my fancy's the greatest painter o' them a', and has a maist magnificent imagination. What a glorious glow and glitter o'battlements hanging ower the crested head o' the Macedonian Monarch, marching afore his bodyguard, while the laing distance is a firest o' spears and lances. The Diogenes, like a tinkler at the door o' his bit blanket tent, geein' a lesson, which he was well able to do, to the son of Jupiter Ammon. The tent's far better than a tub, for historical truth canna be said to be wranged when it's sacrifice to the principles of a lofty art. A fountain playing close at hand in the shade, and the builders and the sculptors still beautyfying every quiet place with pensive images'.

Diogenes, founder of the philosophical school of Cynics, lived in a barrel, being an advocate of self-sufficiency. When asked by Alexander whether there was anything he could do for him, Diogenes was said to have replied that he could get out of his light. This is presumably the visit that is recorded here.

Overleaf

THE GREAT DAY OF HIS WRATH 1852

Oil. 196 x 302.7

Signed 'J. Martin 1852'

Tate Gallery

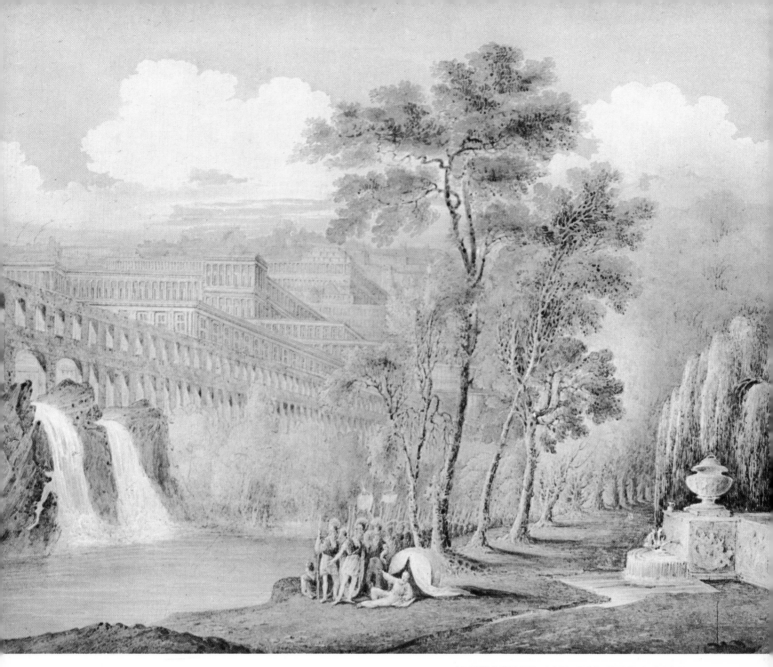

ALEXANDER AND DIOGENES 1827

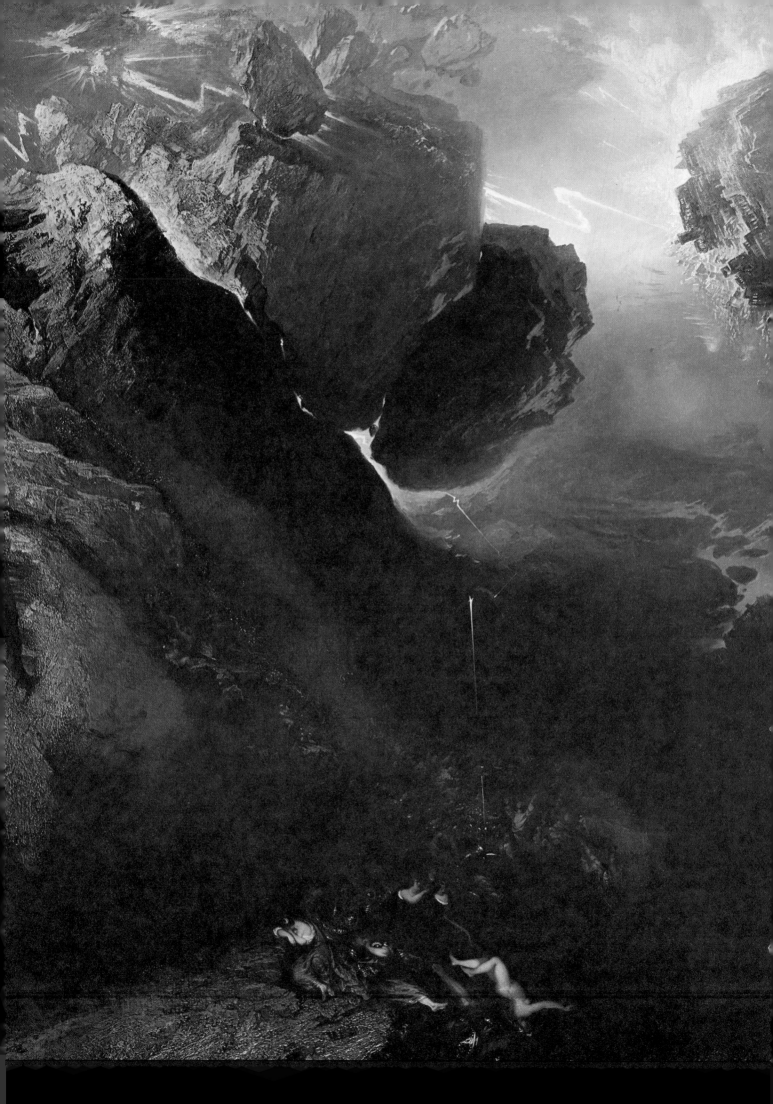

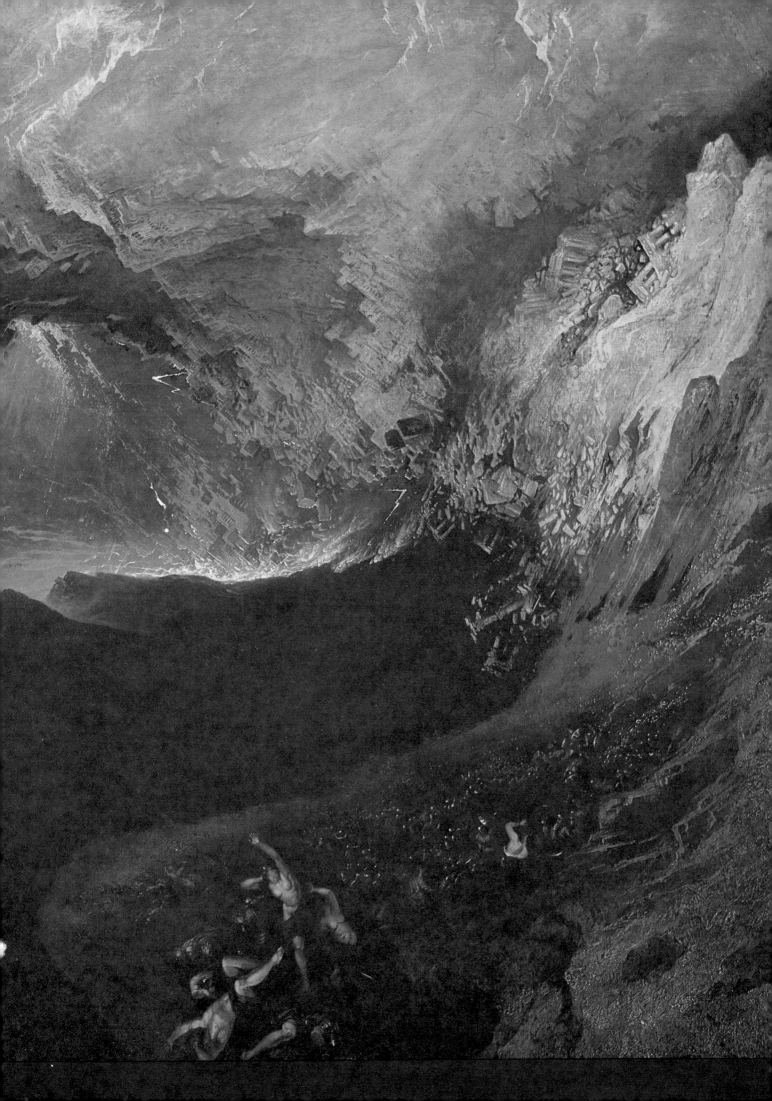

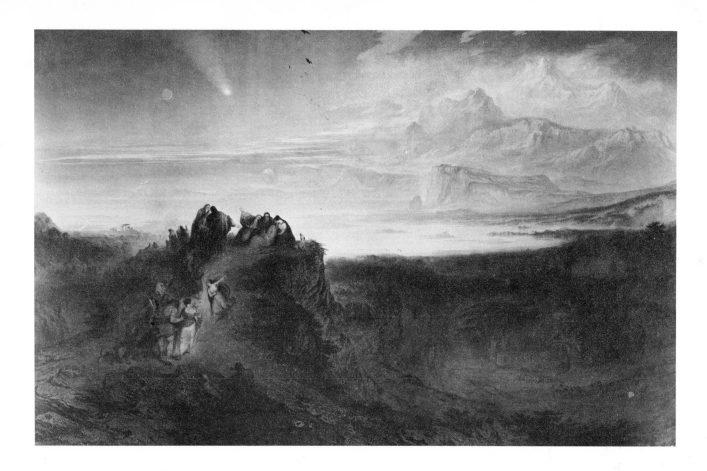

THE EVE OF THE DELUGE 1840
Oil. 143.5 x 217.2
Signed 'J. Martin 1840'
Her Majesty the Queen

Left

THE DELUGE 1834
Oil. 167.6 x 259.1
Signed J' Martin 1834'
Charles Jerdein

THE DELUGE SERIES 1826 -1840

In April 1840 Martin published a pamphlet explaining his conception of *The Deluge,* in reference to three paintings of the subject: *The Eve of the Deluge, The Deluge* and *The Assuaging of the Waters.*

As mentioned earlier, Martin exhibited a painting of *The Deluge* at the British Institution in 1826, issuing at the same time a small pamphlet describing the picture. It was followed by a mezzotint in 1828, also accompanied by a descriptive catalogue. However, it was not until 1840 that the two companion paintings were exhibited, both at the Royal Academy.

The original painting of *The Deluge* is now lost, and the history of it is complicated by the appearance of the present version dated 1834. The problem arises from the fact that according to Thomas, the original was 'after much working up, exhibited at the Royal Academy in 1837', having been previously shown in Edinburgh in 1829. *The Deluge* was also exhibited at the Louvre in 1834. Mr. Jerdein's picture shows no signs of having been altered at all.

Another piece of information is contained in a letter from a Mr. Peter Thomsen of Edinburgh dated 1922, in which he offers his painting of *The Deluge* by John Martin to the Tate Gallery. He does not state the size, but says that it was painted in 1837 and enclosed a photograph, now faded, which shows a composition very close to that of the mezzotint, which the 1834 picture does not resemble in detail.

Mr. Thomsen's painting could not have been the version exhibited in Edinburgh in 1829 because it does not fit Christopher North's description: 'Yon picture's at first altogether incomprehensible. But the longer you glower at it, the mair intelligible does a' the confusion become. Phantom's, like the tops of mountains grow distincter in the gloom, and the gloom itself that at first seemed clud, is noo seen to be water. What you thocht to be snowy rocks, become sea-like waves, and shuddering you cry out, with a stifled voice,"Lord preserve us, if that's the Deluge." But where are a' the folk? That canna be them, that huddle of specks, liek flocks o' sheep driven to and fro by the tempest! It is! The demented survivors o' the human race a' gathered together on the ledges o' rocks - there's thousands on thousands o' folk broken out of Bedlam and as mad'.

This is much closer to the 1834 picture, where there is hardly any detail. Mr. Thomsen's version is of a much closer view of the scene, more in keeping with the companion pictures. It is possible therefore that it might be the original 'worked up' or a new painting, either of which could have been exhibited at the Royal Academy. At any rate, what is almost certain is that the 1834 version was exhibited at Atherstone's Gallery and bought soon afterwards by Scarisbrick. Despite the care taken by Martin to explain his paintings, in a letter to Atherstone (November, 1841) thanking him for a paper setting forth his understanding of the painting, he complains of the 'incomprehensibility (sic) of some people, more especially as regards this my favorite (sic) picture'. Martin also gives a practical reason for placing the ark 'on the summit of a rock (4000 feet high by the scale with which the picture is worked)' - presumably one of the reasons the painting was not recognized as the Deluge - which was so that it would be 'out of danger, from whence the waters rising so high it would be gently and safely floated on the expanse of waters'.

When exhibited at the British Institution in 1826 *The Deluge* was accompanied by a quotation from *Genesis* as well as a short introduction by Martin. The same quotation from *Genesis* was in the Royal Academy catalogue, but this time followed by an extract from Byron's *Heaven and Earth*:

Shall prayer ascend,
When the swoln clouds into the mountains bend
And burst,
And gushing oceans every barrier rend,
Until the very deserts know no thirst?
Where shall we fly?
Not to the mountains high;
For now their torrents rush with double roar,
To meet the ocean, which, advancing still,
Already grasps each drowning hill,
Nor leaves an unsearched cave.

Two other paintings which made up the trilogy of Deluge scenes were both exhibited in 1840 at the Royal Academy. Both subjects had been previously done by Martin. He had engraved the *Eve* for John Galt's

The Ouranoulogos, 1833, and showed a watercolour of *The Assuaging* at the New Society in 1838.

The large oils may have been painted on the suggestion of Prince Albert, who had seen *The Deluge* in Martin's studio on one of his visits. The Prince Consort at any rate commissioned the *Eve,* and the Duchess of Sutherland, who had accompanied her husband at one of his sittings for *The Coronation,* commissioned *The Assuaging of the Waters* not long afterwards.

Martin wrote about the *Eve*: 'I have endeavoured to portray my imaginings of the Antediluvian World, and to represent the near conjunction of the Sun, Moon and a Comet as one of the warning signs of the approaching doom . . .

Upon a rock in the foreground are some patriarchs and the family of Noah, anxiously gathered round Methuselah who is supposed to have directed the opening of the Scroll of his father, Enoch, whilst agitated groups of figures, and one of the Giants of those days , are hurrying to the spot where Noah displays the scroll; and Methuselah having compared the portentous signs in the Heavens with those represented on the scroll, at once perceived the fulfilment of the prophecy - that the end is come and resigns his soul to God.' After some anonymous blank verse, which is liberally distributed throughout the catalogue, Martin lists his authorities: *The Book of Enoch,* preserved by the Ethiopians; Hebrews, Jude, Adam Clarkland's *Josephus' Antiquities.*

It should be pointed out that the Ark is 'in the distance . . . on a lofty promontory', as it appears in *The Deluge.* Martin does not explain how Noah and his family managed to be so far away from the Ark and were able to return to it before the Flood.

The Eve of the Deluge was re-exhibited at the British Institution in 1841 and delivered to Buckingham Palace shortly thereafter. Martin published a very fine large mezzotint of it dedicated to Prince Albert in October 1842.

The Assuaging of the Waters came to light after the Laing exhibition of 1951. It was described by *The Observer* as 'Perhaps the most beautiful of all his productions'.

Martin's description of the trilogy continues: 'In this picture I have chosen that period after the Deluge, when I supposed the sun to have first burst forth over the broad expanse of waters gently rippled by the breeze, which is blowing the stormclouds seaward; in the distance is the Ark in the full flood of sunlight. The direction of the land is indicated by the tops of mountains which are beginning to appear . . . A serpent, the first tempter to sin, and therefore the original cause of the Deluge, is circled, drowned, round the branch upon which is the raven sent by Noah . . .'

Overleaf

THE ASSUAGING OF THE WATERS 1840
Oil. 132 x 203. 2
Signed 'J. Martin 1840'
The General Assembly of the Church of Scotland

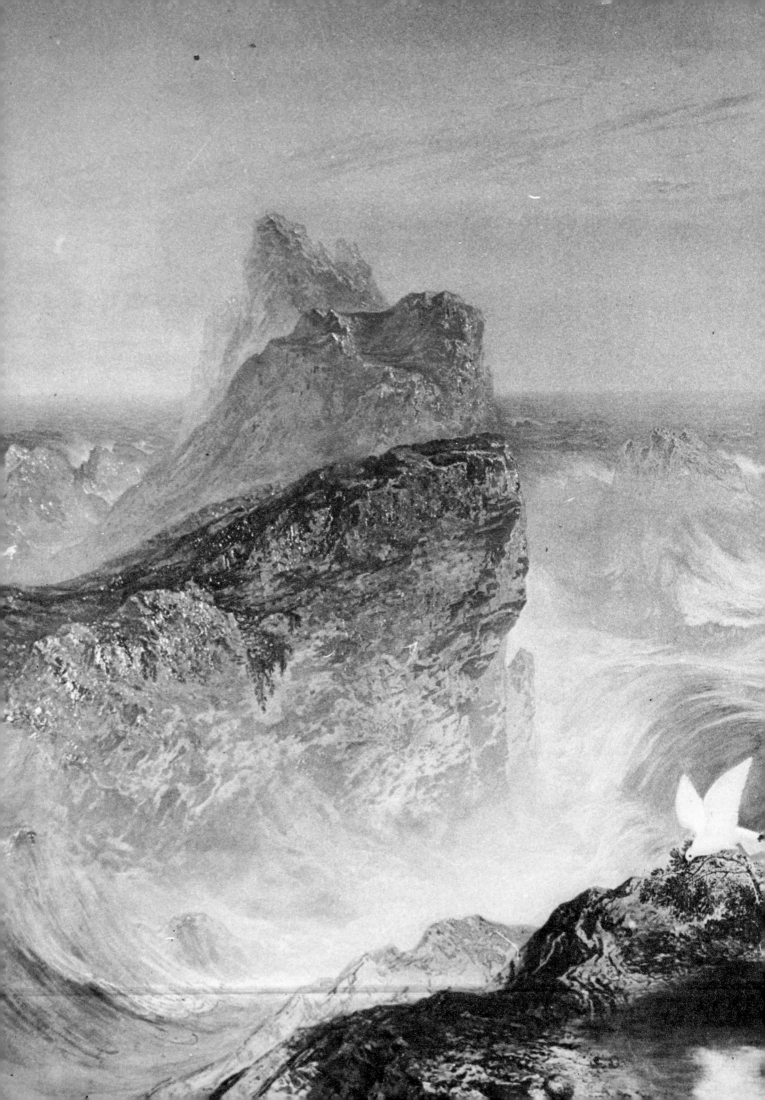

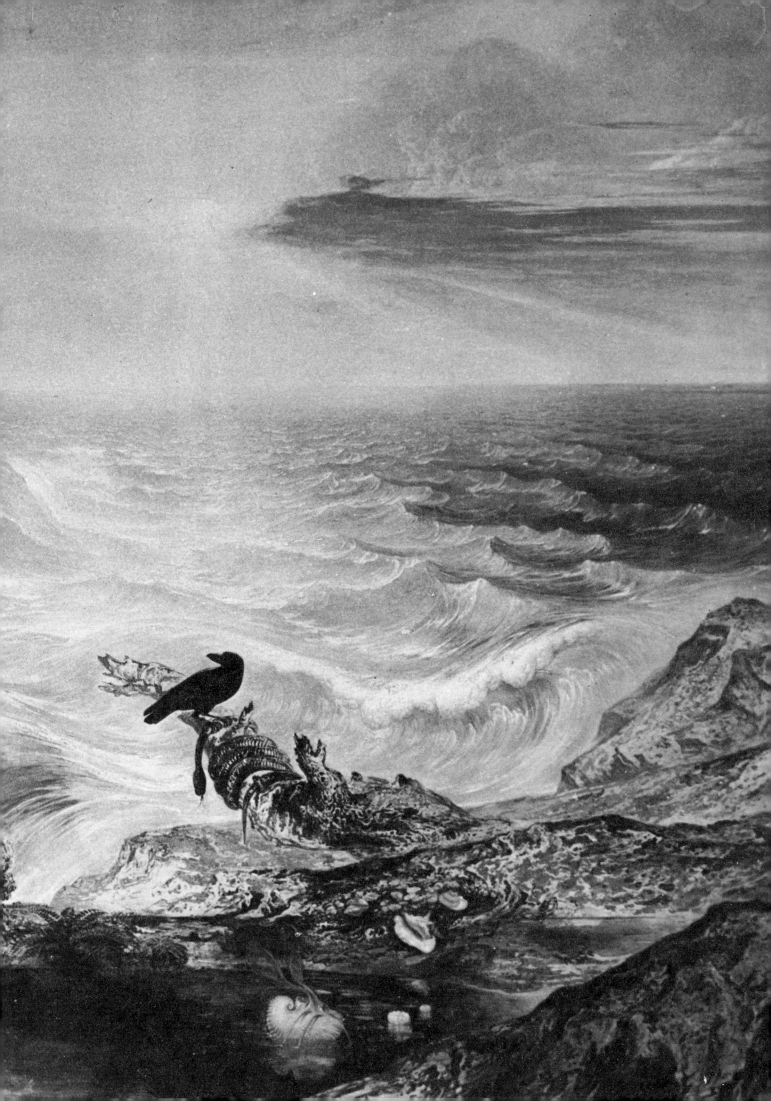

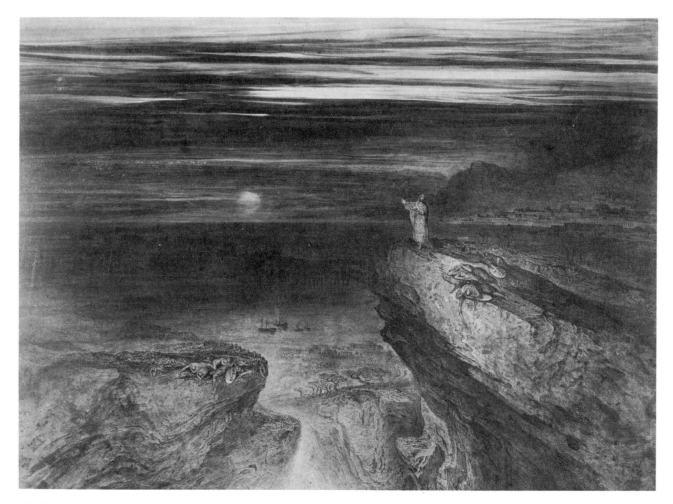

THE LAST MAN
Watercolour 47.6 x 70.5
Not inscribed Laing Art Gallery
A watercolour of this title was exhibited at the New Watercolour Society in 1833. Four stanzas of Thomas Campbell's poem *The Last Man* were in the catalogue, beginning:
The sun had a sickly glare,
The earth with age was wan,
The skeletons of the nations were
Around that lonely man...
Alfred Martin published a mezzotint of the same title after a drawing by his father in 1836.

THE CAVE
Sepia. 20 x 28.8
Signed 'J. Martin'
Private Collection
Probably dating from 1830-40, this sepia resembles the style of Danby's watercolours.

THE CRUCIFIXION 1834
Mezzotint. 53.3 x 76.2
Victoria and Albert Museum
The print was dedicated to the Archbishop of Canterbury and the S.P.C.K. and published on 1st July, 1834 by Francis Moon who had paid Martin £1000 for the plate. A sixteen page key was also issued, the bulk of which consisted of extracts from the poems on the subject by Robert Montgomery and Dr. Croly. The Crucifixion was Martin's favourite New Testament story and as well as watercolours in Nottingham and the Victoria and Albert Museum, which also has a bistre drawing, Ruthven Todd has a small pencil-and-ink drawing. Martin published a small engraving of it the following year, and there are several other engravings after his design, including one by Alfred in *The Wars of Jehovah* (1844).

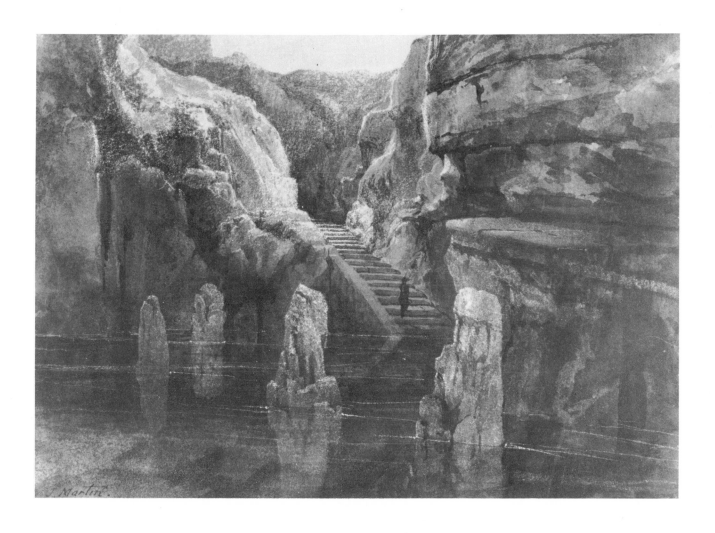

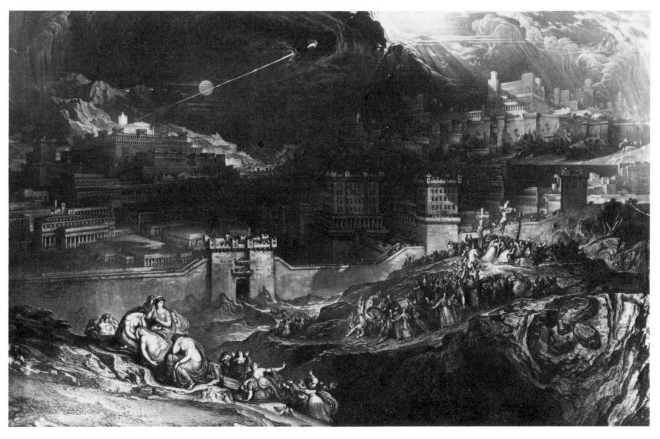

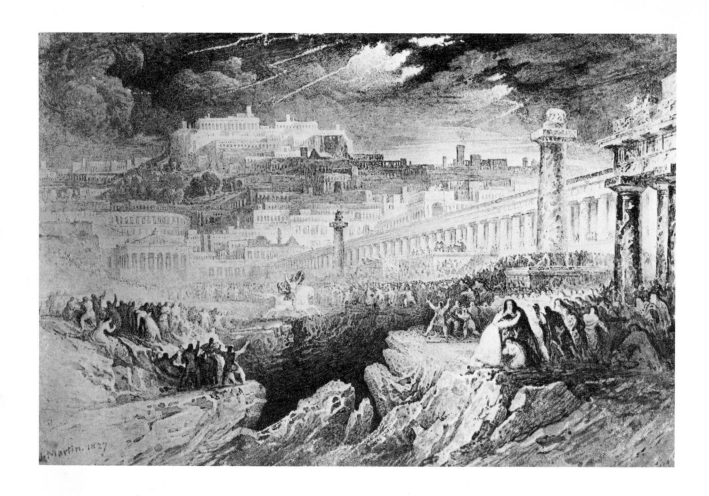

MARCUS CURTIUS 1827
Sepia. 11.1 x 18.1
Signed 'J. Martin 1827'
Laing Art Gallery
A watercolour of this title was exhibited in the British Artists in 1831, but there is no record of an exhibited oil painting. Martin's twelfth large engraving was of the same subject and published in July 1837, for which there was no descriptive pamphlet; but in a letter of 27th January, 1849 on the back of the frame of the sepia he relates the story: 'Marcus Curtius was a Roman youth who devoted himself to the Manes for the safety of his country, about 360 B.C. A wide gap, called afterwards "Curtius Lacus" had suddenly opened in the forum and the oracle said that it would never close before Rome threw into it whatever it had most precious. Curtius immediately perceived that no less than a human sacrifice was required. He armed himself, mounted his horse and solemnly threw himself into the gulf which instantly closed over him'. (Livy vii, c. 6; Valerius Maximus 5, c. 6)
The print was not successful and impressions are very rare. There are several versions in oil (Laing, Sir Leigh Ashton, Lord Kinross), and a small steel engraving by H. Le Keux was the frontispiece to *Forget Me Not* published by Ackermann in 1829. Of this 10,000 copies had been sold and the publisher sent Martin the plate to show that it was still good enough for many more impressions.

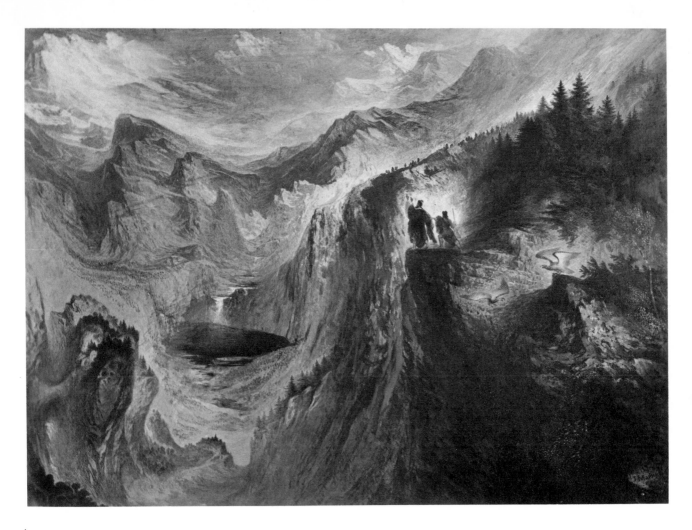

MANFRED ON THE JUNGFRAU 1837
Watercolour. 38 x 53.9
Signed 'J. Martin 1837'
Birmingham Art Gallery
An oil painting of Manfred was exhibited at the British Artists in 1826 with the following quotation from Byron's *Manfred* (1817):

Ye topling crags of ice,
Ye avalanches, whom a breath draws down,
In mountainous o'erwhelming, come and crush me.
I hear ye momently above, beneath -
Crash with a frequent conflict; but ye pass,
And only falls as things that still would live.

Such would have been for me a fitting tomb,
My bones had then been quiet in their depth;
They had not then been strewn upon the rocks
For the wind's pastime - as thus - they shall be -
In this one plunge. Farewell, ye opening heavens;
Look not upon me thus reproachfully -
You were not meant for me - Earth take these atoms

As Manfred is in the act of springing from the cliff, the chamois hunter seizes and restrains him with a sudden grasp.

Hold madman! - though aweary of thy life,
Stain not our pure vales with your guilty blood.

A watercolour in the Christies sale of 1854 was possibly this one, where it was described: 'Manfred on a pine-clad hill, rich in hues and tints, is represented as looking towards an Alpine region of oblivion and death, of blue peaks where the avalanches hang, and beneath which the glaciers creep in their slow but certain progress. The contrast between life and death is well represented by the warm and cold of this picture'.

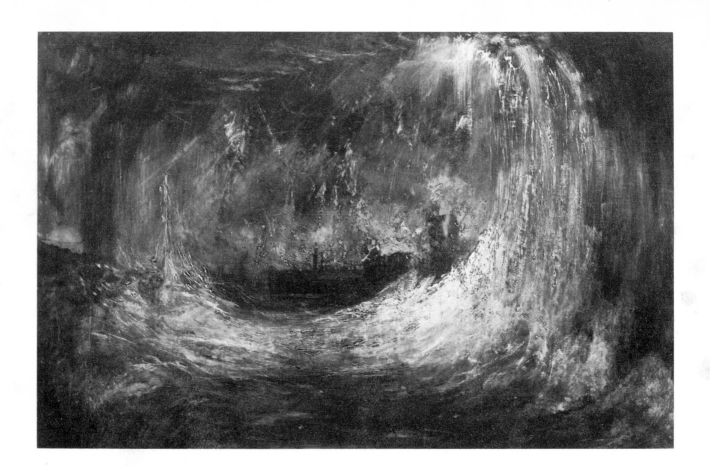

STUDY FOR CHRIST STILLETH THE TEMPEST
Oil. 34.3 x 54.6
Not Inscribed
Private Collection
Formerly known as *Stormy Sea and Burning Town,* the present title has been suggested by the owner, who has dated it circa 1830-40. The original, now lost, was exhibited at the Royal Academy in 1843, of which Ruskin said: 'this is a childish exaggeration because it is impossible by the laws of matter and motion, that such a breaker should ever exist' - criticism which lends credence to the appropriateness of the new title. However, despite Ruskin's criticism, the sketch is one of the most Turneresque of Martin's works, both in conception and handling, the vortex-like construction being used quite often by both artists. An example of this looser handling of paint in a landscape is *Woodland Scene,* dated 1845 and in a private collection.

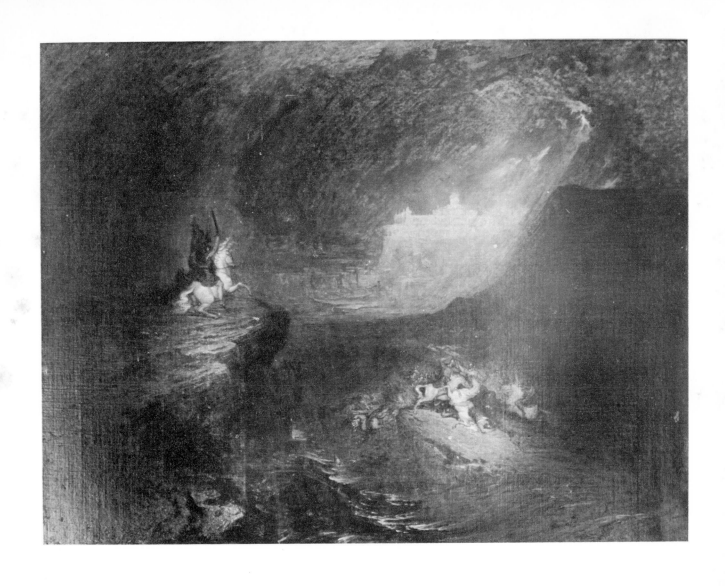

BATTLE SCENE WITH CITY IN THE BACKGROUND 1837
Oil. 89.5 x 119.7
Signed 'J. Martin 1837'
Torre Abbey
A completely unrecorded work for which no satisfactory title has been found.

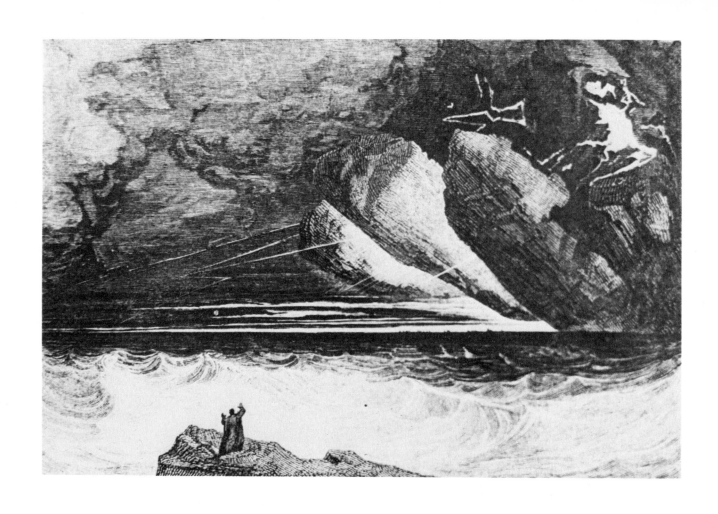

THE OPENING OF THE SEVENTH SEAL 1836 after Martin
Wood engraving. 5.7 x 10.2
Not inscribed
Victoria and Albert Museum

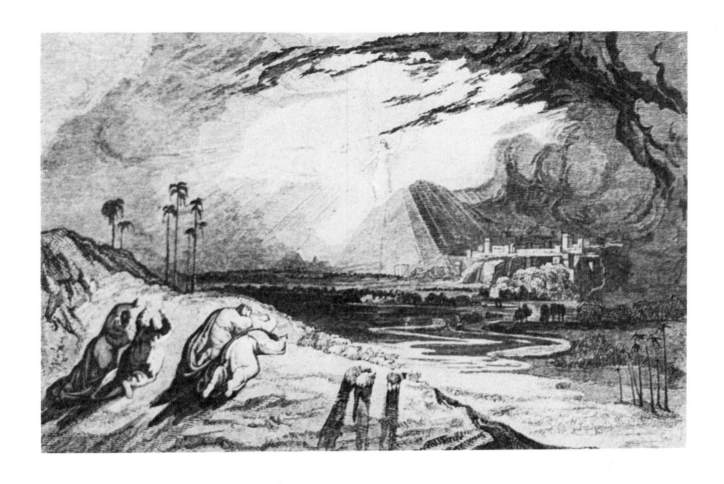

THE ANGEL ANNOUNCING THE NATIVITY 1836 after Martin
Wood engraving. 5.7 x 10.2
Not inscribed
Victoria and Albert Museum
These are Numbers 44 and 19 respectively in the *Illustrations of the New Testament* by Westall and Martin. The complete and bound illustrations were published in 1836 with descriptions by the Reverend Hobard Caunter, although the parts, each consisting of 8 wood engravings, were issued from March 31st to April 1st, 1835.
Ackermann's announced a small engraving of *The Seventh Seal* by Martin in 1837 but no impressions of it have come to light.

85

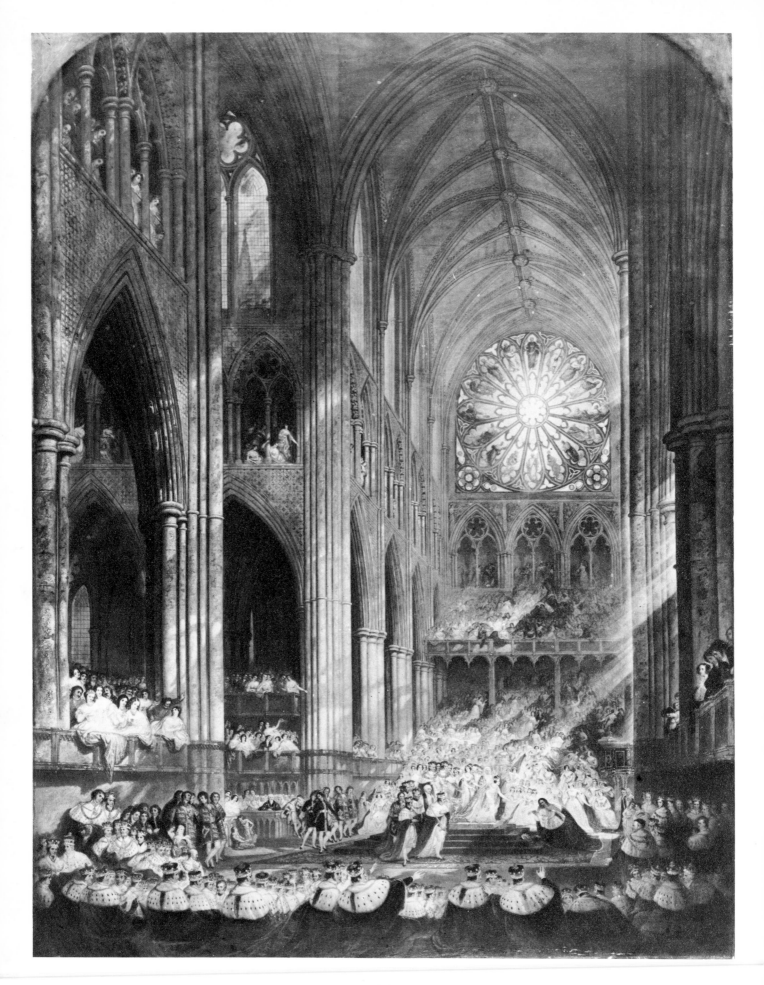

THE CORONATION OF QUEEN VICTORIA
Oil. 23.5 x 181.6
Signed 'J. Martin 1839'
Tate Gallery

Queen Victoria was crowned in Westminster Abbey on June 18, 1838. Martin, no doubt present at the ceremony, started painting the scene a few months later, making several studies in the Abbey. Although he had not attempted portraiture since his first and only commission when he was still in Newcastle, he made a decision which was the cause of a great improvement in his financial affairs, namely to introduce into the composition portraits taken from life and engravings of many of the prominent persons present on the occasion, employing Charles to help with some of the figures. Earl Grey, Lord Howick, the Duke of Sutherland, and many others sat for him in his studio, and seeing the works in his gallery either bought or commissioned others.

Thomas wrote on 26 October, 1839 'He is now going on in glory and working indefatigably'. It was finished at the end of the year and sent to Buckingham Palace, but it was not purchased, and it was not until three years later that it was first exhibited, probably at Atherstone's Gallery in the Haymarket. The *Art Union* of June 1, 1844, gave the following notice: 'It is a gorgeous and in some respects a happy mingling of fact and fancy, being rich in all the peculiarities of the painter. It may not stand the test of the severer rules of art, but it is a brilliant transcript of a scene which, although occurring in our own time, may claim something of the licence of romance. The point of time selected is that which permits the artist to set the mighty crowd in motion, for when Lord Rolle fell on the steps of the throne, not only did the young and gentle queen rise to assist him, but all her subjects, in duty bound, rose with her. The picture is a very interesting one, with abundant evidence of genius; and will be very acceptable to those whose imagination figure forth a subject far more grand, exciting and imposing than the cold copies of bits of the ceremony by Leslie, Parris and Hayter'. (Leslie's picture *The Queen Receiving the Sacrement* . . . was exhibited at the Royal Academy in 1843)

Charles Scarisbrick bought *The Coronation* for 2000 guineas. And when Atherstone bought it at the Scarisbrook sale in 1861 (for a mere 51 guineas) he mentioned 'the extraordinary effect produced by the sudden outburst of sunshine almost at the moment when the crown was placed upon the head of the Queen. This effect was not likely to be unnoticed by one so keenly sensible as Martin to the magic of chiaroscuro; and he has presented it with his customary power.'

In fact his 'customary power' was such that (according to Thomas) one day Earl Grey was in the studio and asked Martin to draw the blind as the sun was streaming across the painting and he was not able to see it properly.

Overleaf

THE DESTRUCTION OF TYRE 1840
Oil. 83.9 x 109.5
Signed 'J. Martin 1840'
Toledo Museum of Art

Painted in a sombre, grey monochrome, with only slight touches of colour, the work was acquired by Toledo soon after the Laing Exhibition of 1951. It is another unrecorded work, and bears similiarities to the preceding study. It is also close to the wood engraving of the same subject in the Westall and Martin Bible illustrations.

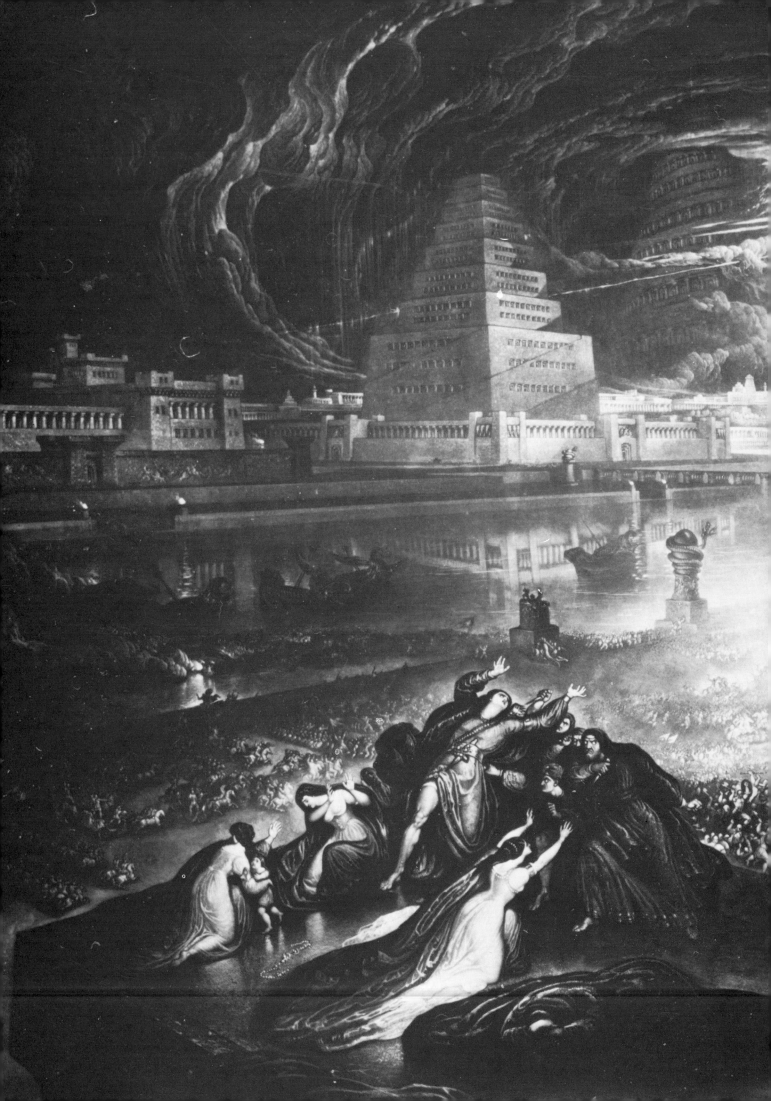

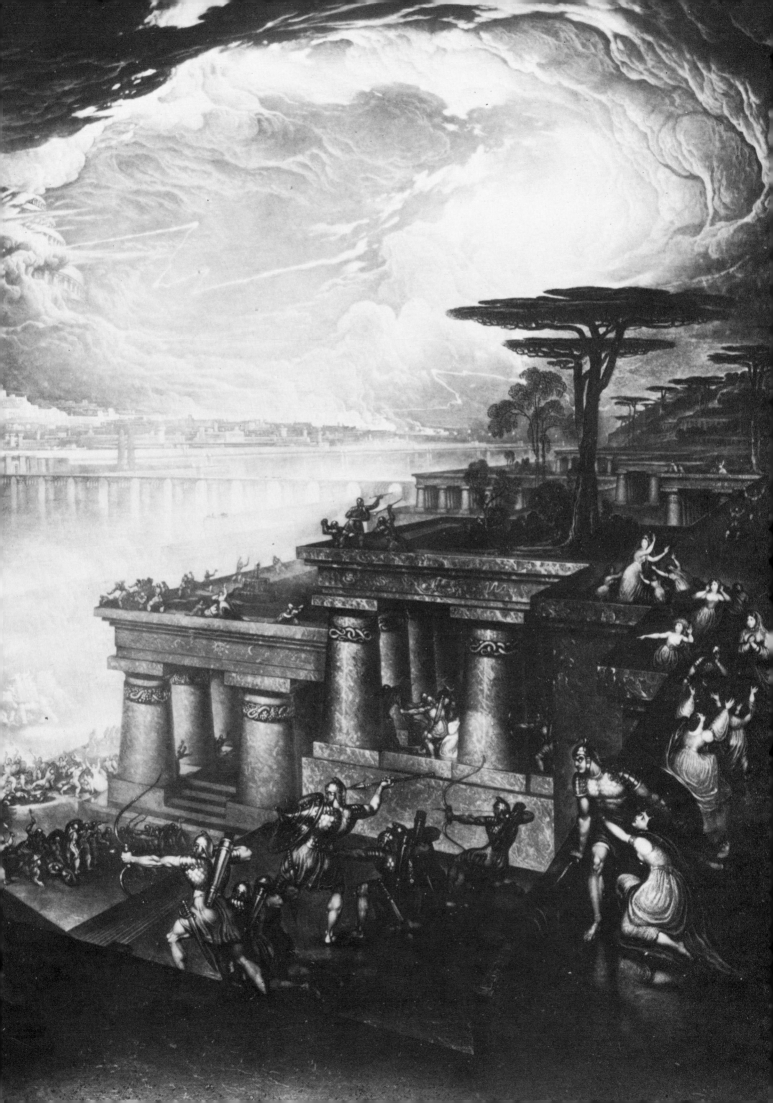

RICHMOND PARK 1843
Watercolour. 27.9 x 71
Signed 'J. Martin August 23, 1843'
Victoria and Albert Museum
Martin often painted in Richmond Park and four of these views were exhibited in the Royal Academy in 1844. In the Lindsey House sale three views of Richmond Park near Ham Gate appeared in the catalogue, the titles printed in especially large type.

COAST SCENE WITH THUNDERSTORM
Watercolour. 15.9 x 24.2
Signed 'J. Martin'
British Museum
Beachy Head can be seen in the distance. As it is a late work it might be the watercolour exhibited at the Royal Academy in 1843: *Study from Nature on the Sussex Coast.* Martin exhibited several landscapes of Sussex, among them were views of Brighton, Devil's Dyke, Eastbourne, Pevensey, Shoreham and Worthing.

SOLITUDE 1843
Oil. 50.2 x 87.7
Signed 'J. Martin 1843'
Private Collection
Several of Martin's landscapes are very similar to those of his near contemporary, the German painter, Caspar David Friedrich. It could be said that they share the same obsession with death throughout their respective *oeuvres.* *Solitude* is undoubtedly the closest to Friedrich, particularly his *Monk by the Sea,* 1809. Though *Solitude* is dated 1843 it was not exhibited until the Royal Academy exhibition of 1846, where the following quotation had been appended: 'Ye woods and wilds, how well your gloom accords with my soul's sadness.' It is a strange coincidence that Martin's friend and rival B. R. Haydon died in June of that year. An engraving of this title after a drawing by his father was exhibited by Alfred Martin at the British Artists in 1832.

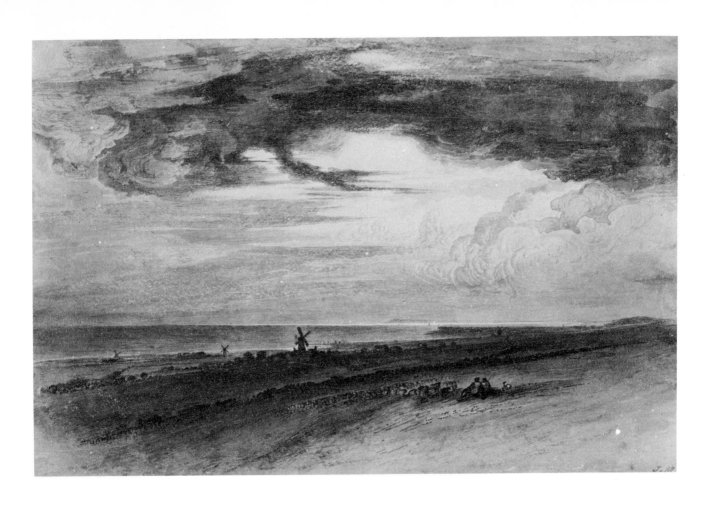

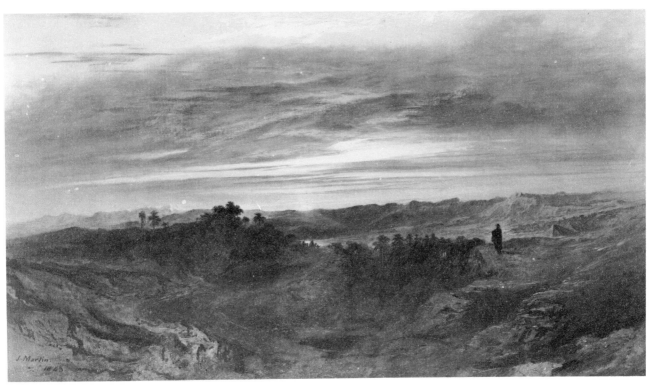

91

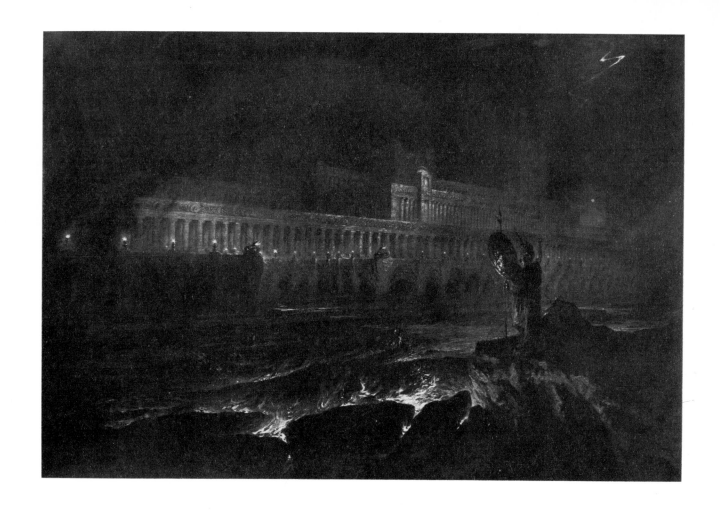

PANDEMONIUM 1841
Oil. 123.2 x 184.2
Signed 'J. Martin 1841'
H. B. Huntington-Whiteley
The painting is based on the illustration to Book 1, line 710, of Milton's *Paradise Lost*:
Anon out of the earth, a fabrick huge
Rose like an exhalation, with the sound
Of dulcet symphonies and voices sweet,
Built like a temple, where pilasters round
Were set, and Dorick pillars overlaid
With golden architrave . . .
However, the architecture is now far less exotic and thoroughly 19th century in character, closely resembling Carlton House Terrace and similar to Martin's own designs for the Embankment.
The subject had been one of the great attractions of de Loutherbourg's *Eidophusikon* shown in 1782 and 1786, and it also had been used by Burford in his *Panorama in Leicester Square* in 1829, influenced greatly by Martin's mezzotint already mentioned.
Another version, attributed to Martin, is in the Tate Gallery.

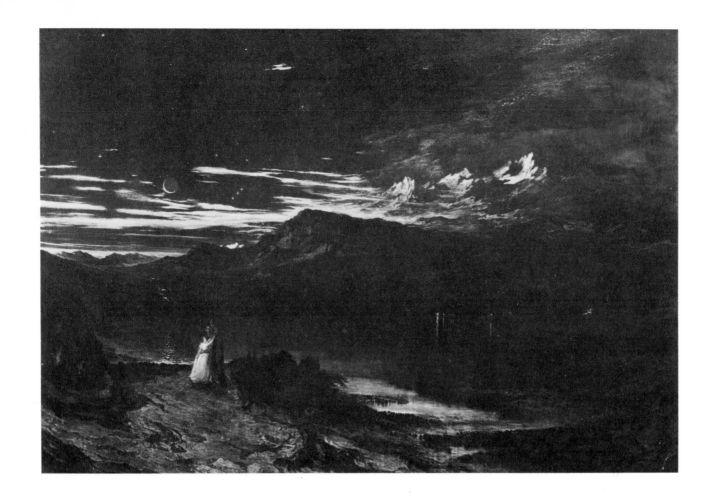

ARTHUR AND AEGLE IN THE HAPPY VALLEY 1849
Oil. 122.5 x 183.5
Signed 'J. Martin 1849'
Laing Art Gallery

The only painting by Martin in the 1849 Royal Academy exhibition. It was inspired by Sir Edward Bulwer Lytton's *King Arthur* published the previous year, a quotation from which was in the catalogue, beginning: 'Behold how Alp on Alp shuts out the scene . . .' Bulwer inquired after the price of the picture and in his reply (7 April 1849) Martin wrote of it: 'Your truly beautiful poem has proved so rich a source of imagination that in endeavouring to illustrate the poetry, I have represented a lovely night I saw some twenty years ago, which was so remarkable for the exceeding clearness of the air and the splendour of the heavenly bodies as to have never been effaced from my mind. If I fail in doing justice to the poet, I trust that I shall please the astronomers, as I have taken every pain to make my picture astronomically correct.'
Despite Martin's reduction in price to Bulwer, he failed to buy it and it was re-exhibited at the British Institution in 1851 with another quotation from the same poem:
Now, as Night gently deepens round them while
Oft to the moon upturn their happy eyes -
Still, hand in hand, the range the lulled isle,
Air knows no breeze, scarce sighing to their sighs;
No bird of night skrieks bode from drowsy trees,
Nought lives between them and the Pleiades.
Martin was among the first of the many artists and writers to be supported by Bulwer (*England and the English,* 1833, contained a lengthy eulogy on Martin) among whom were Haydon, Thomas Campbell, Swinburne, Dickens, Matthew Arnold and Maclise.

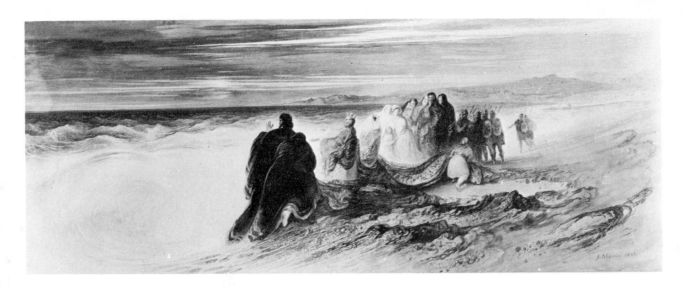

CANUTE REBUKING THE FLATTERY OF HIS COURTIERS 1842
Watercolour. 31.1 x 82.5
Signed 'J. Martin 1842'
Laing Art Gallery

At the time Martin was working on this watercolour and an oil painting of the same subject exhibited at the Royal Academy in 1843, he was also painting a life-size cartoon of *The Trial of Canute* (10 x 15 feet) for the competition for the decoration of the new Houses of Parliament. As the cartoons were all on paper, most of them have disappeared, Martin's included. Martin was unsuccessful in the competition; and in 1844 Ruskin wrote of *The Trial* which had been exhibited at Westminster Hall: 'Martin has attempted this Denner-like portraiture of sea-foam with the assistance of an acre of canvas; with what success I believe the critics of his last year's *Canute,* had for once, the sense to decide . . . If the time which he must have spent on the abortive bubbles of his *Canute* had been passed in walking on the sea-shore, [he] might have learned enough to enable him to produce, with a few strokes, a picture which would have smote, like the sound of the sea, upon men's hearts forever.'

However, *Canute Rebuking . . .* was awarded the silver medal at the Liverpool Academy later that year despite the criticism, although it is uncertain whether it was the oil or the present watercolour.

THE CORNFIELD 1847
Watercolour. 16.5 x 24.8
Signed 'J. Martin 1847'
Private Collection

There are several similar small drawings in the British and the Victoria and Albert Museums, as well as those that pass through the sale rooms. They represent examples of the small studies which Martin would do on his sketching tours and emphasize his study of nature which is often lost in the larger oil paintings.

A PORT: MOONLIGHT 1847
Watercolour. 23.5 x 33.4
Signed 'J. Martin 1847'
Private Collection

Martin often sketched at night when the effects of the clouds and moon were particularly interesting. Walter Greaves recalled that when his family were living at No. 9 Lindsey Row his father would ring Martin's bell if he thought the appearance of the river at night might please Martin, and the artist would appear on the balcony a few minutes later and begin sketching.

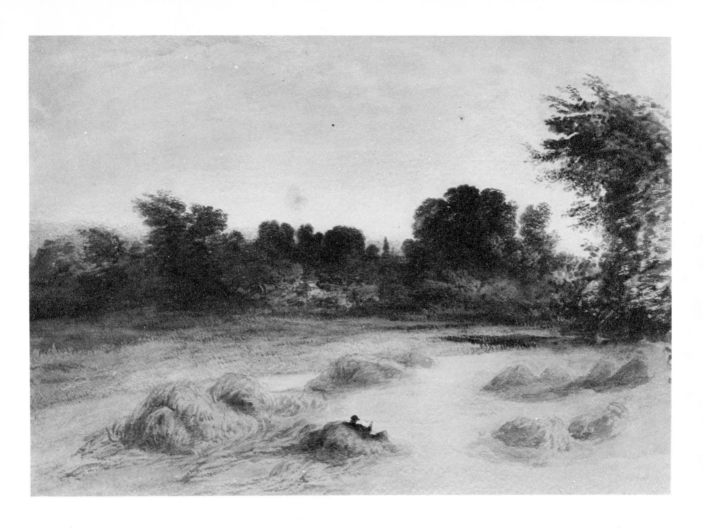

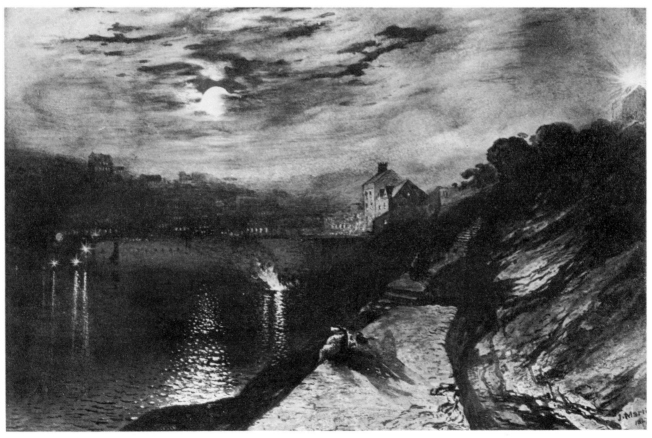

95

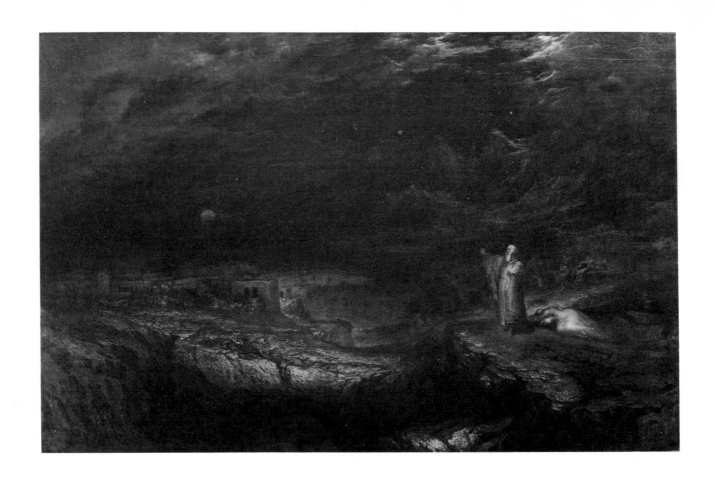

THE LAST MAN 1849
Oil. 137.8 x 214
Signed 'J. Martin 1849'
Walker Art Gallery
After a poem by Thomas Campbell (as in *The Last Man*, 1833); exhibited at the Royal Academy with the following quotation:

I saw a vision in my sleep
That gave my spirit strength to sweep
Adown the gulf of time:
I saw the last of human mould
That shall Creation's death behold,
As Adam saw her prime.

The composition differs from the previous version according to the quotation. Here considerably more emphasis is given to the hero, the skeletons hardly visible on the left of the gorge.

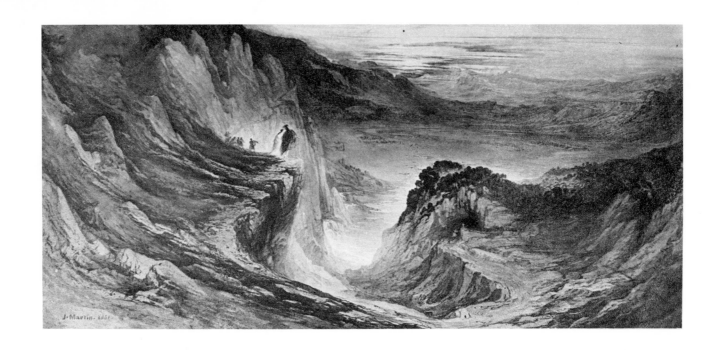

JOSHUA SPYING OUT THE LAND OF CANAAN 1851
Watercolour. 35.5 x 73.7
Signed 'J.Martin 1851'
Manx Museum
This could be a study for a larger, unexecuted painting, possibly a companion to *The Death of Moses* shown at the Royal Academy in 1838. The tiny figure kneeling before a crucifix on the right of the composition would appear to be one of Martin's strange anachronistic quirks, a vision of the future Passion, Martin's favourite New Testament story. *The Death of Moses* also included anachronisms: 'The view comprehends the camp of the Israelites, the Dead Sea . . . Bethlehem . . . The Mount of Olives . . . The full light of the setting sun falls directly upon the birthplace of the Saviour, and the site of the Holy City, Mount Moriah, Calvary is faintly indicated beyond . . . '

97

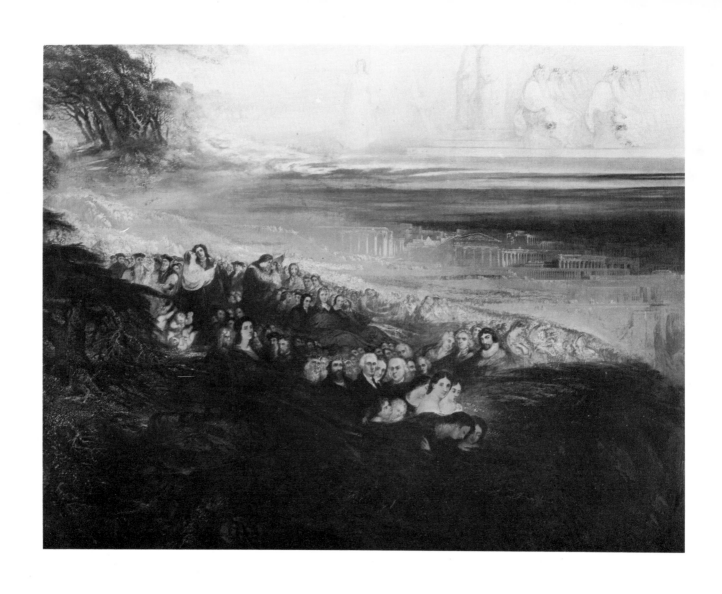

THE LAST JUDGMENT 1853 (detail)
Oil. 198.2 x 324.6
Signed 'J. Martin 1853'
Private Collection

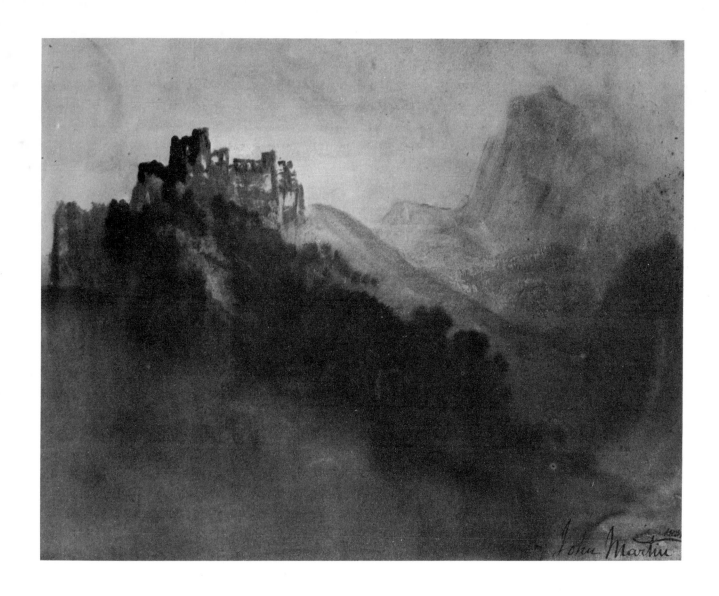

THE RUINED CASTLE 1851
Watercolour. 21 x 27.2
Signed 'J. Martin 1851'
Private Collection
The Castle could be that depicted in *Landscape and Ruins* owned by D. C. Rich, Chicago; illustrated
in Balston . Much later, Victor Hugo produced landscape sketches very similar to Martin's both in style
and feeling. His poetry was much influenced by Martin's early Biblical scenes.

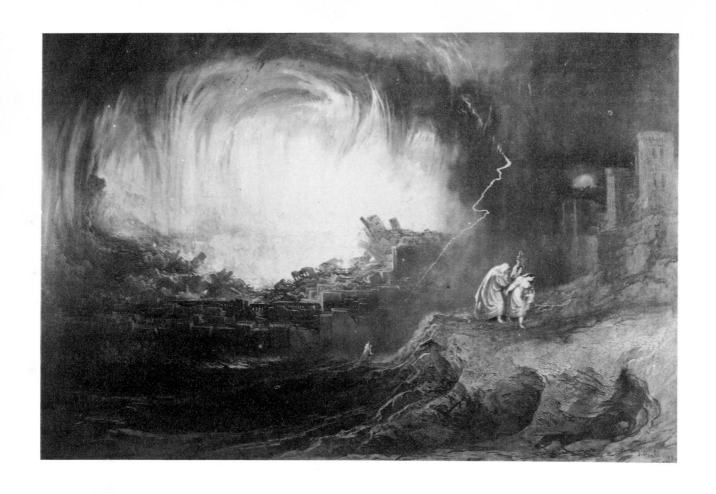

THE DESTRUCTION OF SODOM AND GOMORRAH 1852
Oil. 133.3 x 269.5
Signed 'J. Martin 1852'
Laing Art Gallery
Martin exhibited a painting of this subject in the Royal Academy 1852 with a quotation from Genesis xix: 'But his wife looked back, and she became a pillar of salt . . .' It is not certain, however, whether this was an oil or watercolour. Another version is in the Scarborough Art Gallery, and Martin had engraved the subject for his *Illustrations of the Bible* (1835). Baag did the wood engraving after Martin's design for the Westall and Martin Bible illustrations.

STUDY
Watercolour. 13.3 x 15.9
Not inscribed
Laing Art Gallery

PALESTINE 1867 after Martin by E. Goodall
Steel Engraving. 11.6 x 10.2
Victoria and Albert Museum

The first plate in *Art and Song,* a series of original, highly finished steel engravings from *Masterpieces of Art,* edited by Robert Bell, 1867.

There are four other steel engravings after Martin in the book: *Solitude* and *May Morning* engraved by J. Cousen; *Flamboro Rocks* and *To Evening* by W. Miller.

102

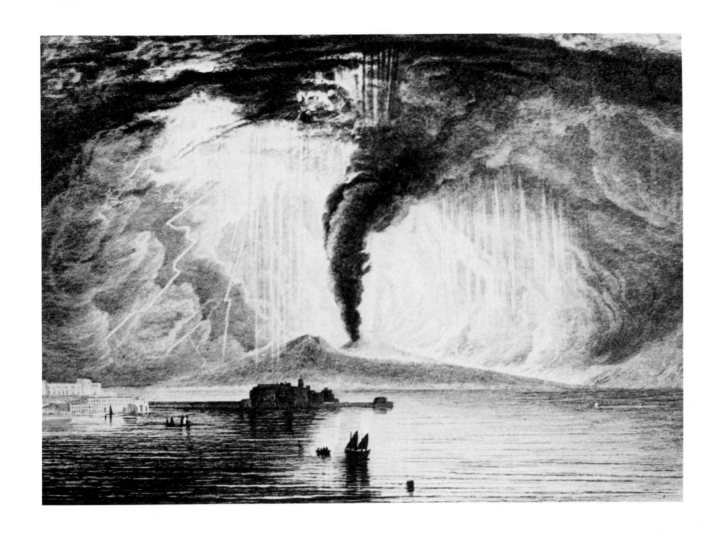

THE ERUPTION OF VESUVIUS after Martin by W.B. Cooke
Steel Engraving. 10.5 x 15.2
Victoria and Albert Museum
From *Pompeii.* Illustrated with picturesque views by W.B. Cooke and a descriptive letterpress to each plate by T. L. Donaldson.

RICHMOND PARK 1850
Watercolour. 29.5 x 59.4
Signed 'J. Martin 1850'
Victoria and Albert Museum

The huge oak tree here depicted is still known as 'Martin's Oak' and stands on the terrace south of Pembroke Lodge. The minute figures indicate Martin's continual obsession with the grandeur of nature which can be seen at the very start of his career in the Sezincot illustration and *Characters of Trees.*

The watercolour could have been that exhibited at the Royal Academy in 1851: 'View, near Pembroke Lodge, Richmond Park.'

Below

JOSHUA
Watercolour heightened with chinese white. 5.4 x 7
Victoria and Albert Museum

Possibly a study for the Westall and Martin Bible illustrations the composition of this sketch relates to that of *The Bard.*

Overleaf

THE PLAINS OF HEAVEN 1853
Oil. 198.2 x 304.3
Signed 'J. Martin 1853'
Private Collection

The Last Judgment, the largest of Martin's paintings excepting the *Fall of Ninevah,* was begun in early 1851 and on June 7 of that year Martin signed an agreement with Thomas Maclean, a printseller on Haymarket, to the effect that Maclean would find a mutually acceptable artist to engrave the picture. Martin would take a third of the net profit.

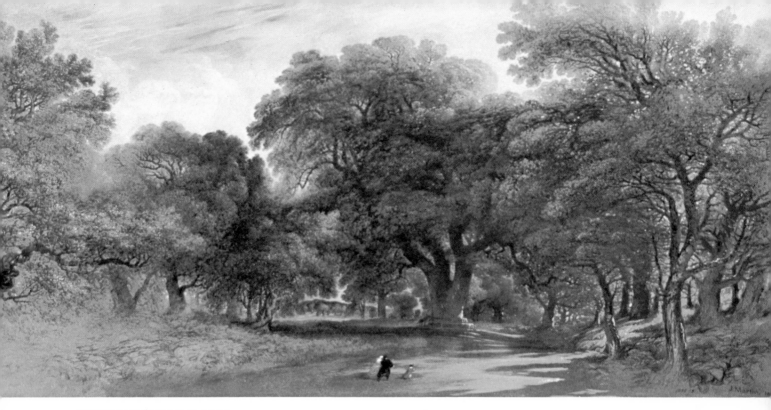

RICHMOND PARK 1850

JOSHUA

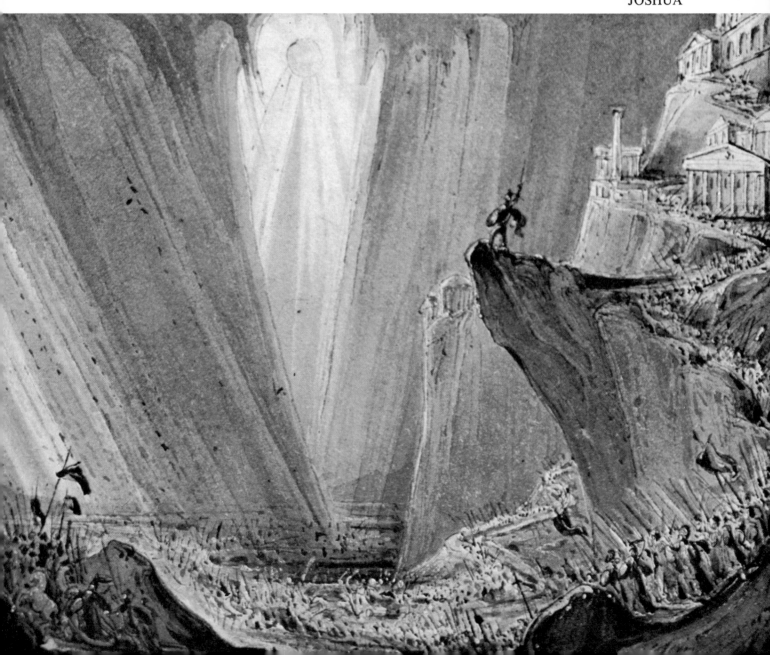

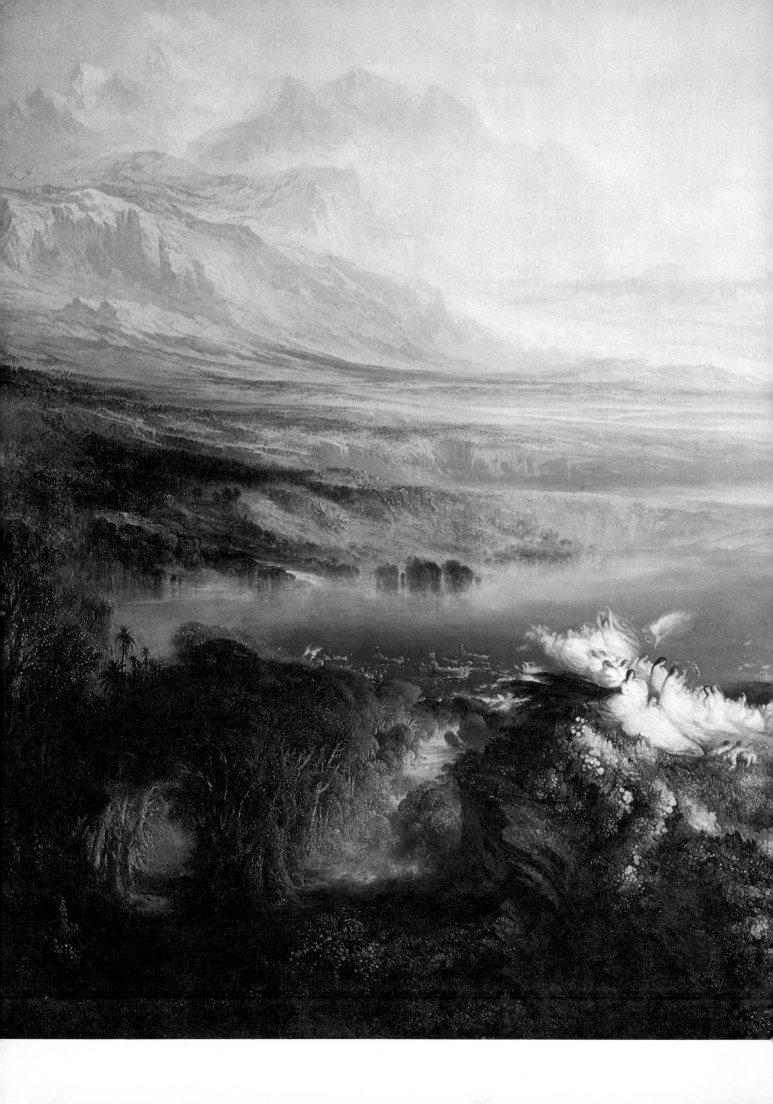

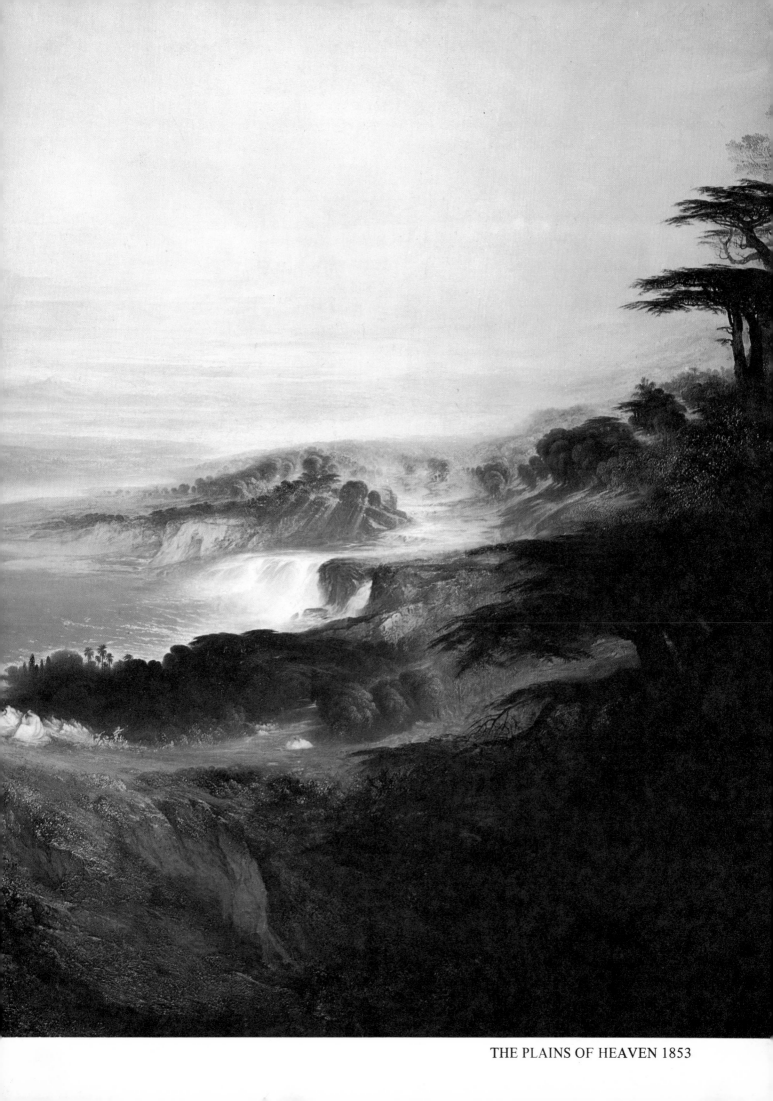

THE PLAINS OF HEAVEN 1853

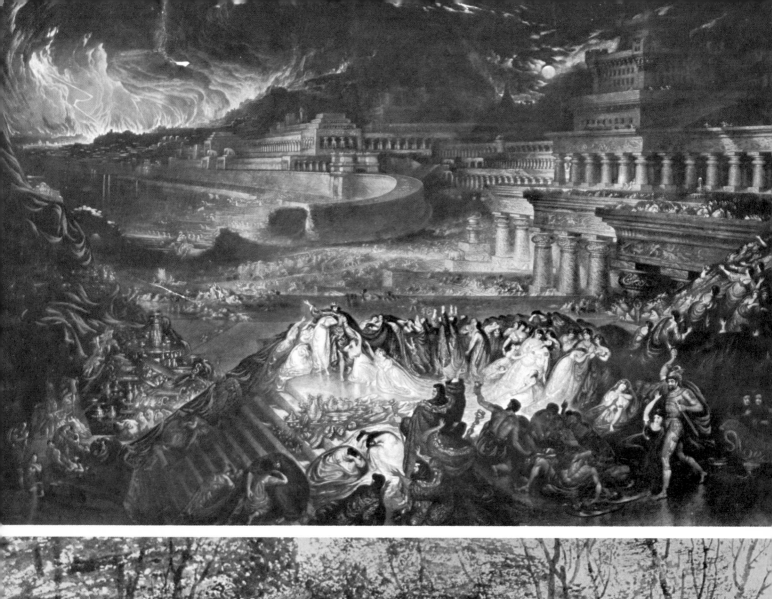

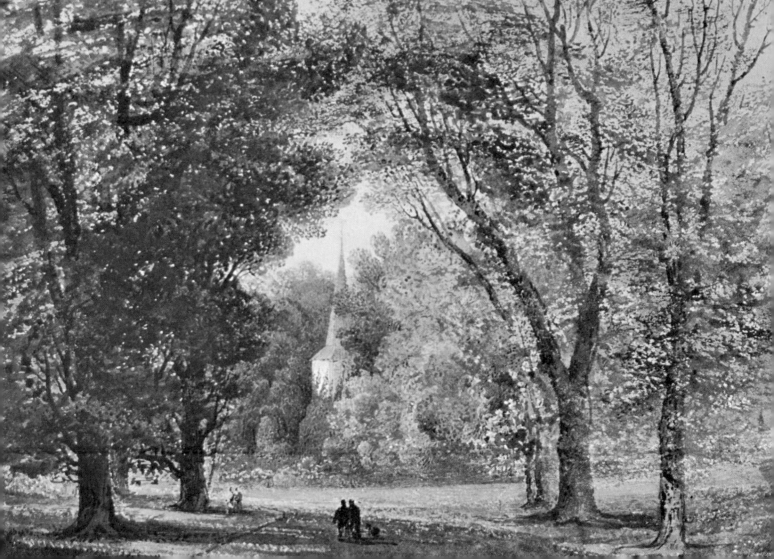

THE FALL OF NINEVAH 1829
Mezzotint coloured by hand. 66.9 x 91.1
Signed 'J. Martin 1829'
Victoria and Albert Museum
Engraved by the artist after his oil painting of the same title dated 1828. It was dedicated to King Charles X of France and published July 1, 1830. Charles X had awarded a gold medal to Martin after seeing his engravings of *Belshazzar, Joshua* and *The Deluge*. The dedication was just in time, for at the end of that month Charles was no longer King.

Ninevah was the largest of all Martin's mezzotints, requiring specially made paper. It also took at least five months of hard work to engrave. The oil painting was first exhibited at the Western Exchange, Old Bond Street in 1828. It was formerly in the Royal Collection in Cairo and had been seen in the Cairo Museum before the revolution. Its present whereabouts are unknown. Martin issued a descriptive catalogue of the painting at the time of the exhibition, giving as usual his sources for the accuracy of the painting and pointing out the important details.

Ninevah was destroyed by the Medes in 612 B.C. They entered the strongly fortified city by breaching the reservoir in its centre and entering through the hole, which can be clearly seen in the print. Ninevah was based on quite a common kind of fortification depicted by Daniell in the *Gateway of Sher Shar's Fort*. Further proof of Martin's familiarity with the Reverend Thomas Maurice's *History of Hindostan* is the inclusion of the *Mundane Egg* which is described in detail by the author and can be seen just to the right of the reservoir, a serpent coiled around it. A variation of the same symbol shows the egg being butted by a bull.

STANMER CHURCH, SUSSEX 1834
Watercolour. 12.2 x 17.8
Signed 'J. Martin September 25, 1834' Victoria and Albert Museum
There were four watercolours at the British Artists in 1835, of which this might be one, though a watercolour of the same title was exhibited at the Royal Academy in 1839. Stanmer Church is four miles from Brighton.

JOHN MARTIN'S ILLUSTRATIONS FOR MILTON'S PARADISE LOST

Illustrated editions of *Paradise Lost* appeared soon after Milton's death and throughout the 18th century. Among the artists who contributed illustrations to the poem were Medina, Cheron, Thornhill, Hayman, Westall, Fuseli, Burney, Barry, Hogarth and Blake.

Martin's affection for the poet is apparent early in his career. Despite many precursors of whose work he must have been aware, Martin's illustrations are not at all derivative - although he may have been influenced by Fuseli, whose Milton Gallery opened in 1799.

This originality is due to several factors: Martin's conceptions of history painting and architectural fantasy were ideally suited to Milton's descriptions; he was working in mezzotint, the first to use the soft steel plate; and lastly, he was both designer and engraver, whereas previously illustrations were not engraved by the artist.

The obvious difference between Martin's illustrations and those of his predecessors (and a continual source of adverse criticism of his history and Biblical paintings), is that Martin emphasized the landscape and architecture where others were concerned with figures. The novelty of his designs lies in his being the first artist to create a sense of place, to conjure up the appearance of Hell, Paradise and Pandemonium. This point was not overlooked by the writer of the prospectus to the parts editions: 'Those only who have seen the Grand Scriptural Paintings of this artist . . . can be duly impressed by the peculiar adaption of his powers to the lofty undertaking of embodying such stupendous and preternatural imagery of the *Paradise Lost*; in which the sublime genius of Milton has given these wonderful descriptions of Heaven, and Hell, and Paradise, and Chaos, and Creation; these, it may be said, without wishing to derogate from the merits of the eminent artists who have already employed their pencils to illustrate this Poem, have not yet treated with a boldness and grandeur kindred to the mighty imagination which created them . . .' This originality was also pointed out by the reviewer in the *Literary Gazette*, following the publication of the first part:

'We know no artist whose genius so perfectly fitted him to be illustrator of the mighty Milton. There is a wildness a grandeur, a mystery about his designs which are indescribably fine. It may be that the figures cannot possess the force and dignity with which the imagination clothes them, but the sweeping elements, the chaos come again, the wonders of Heaven and Hell which existed before the earth was made, are magnificently embodied.'

Martin's one failing was his difficulty with figures and those few illustrations where figures play a prominent part are among the least successful of his designs. However, Martin does not use physical and facial expressions to make the various moods of the poem immediately apparent. He manages to create these moods by skilful variations of light, by immense Claudian vistas contrasted with claustrophobic scenes in forests or sombre, terrifying abysses, on the brink of which the main protagonists often seem about to fall. Martin also employed the technical device, in the later books, of using more etching, which gives a harsher definition and starkness to selected details.

The success of Martin's *Paradise Lost* was immediate and long-lasting, exerting influence on Turner's illustrations (published in 1835) and those of Doré, in particular his *Creation of Light*. The numerous later editions using his illustrations were among the main reasons for the survival of Martin's reputation until the revived interest over the last few decades. They were published by Charles Tilt ('in consequence of the failure of the proprietor of this splendid work,' 1838), Charles Whittingham (1846), Henry Washbourne (1849, 1850, 1853, 1858) and Sampson Low (1866). By this time, of course, the plates were completely worn out and in 1876 Bickers and Sons illustrated their *The Poetical Works of John Milton* with small photographic reproductions of the larger series of mezzotints.

When Martin was commissioned by Samuel Prowett, the American publisher, to illustrate Milton's *Paradise Lost*, in early 1823, his graphic work consisted of *Characters of Trees, Sezincot House* and the two small etchings *Classical City* and *Classical Ruins*. He had not yet published any mezzotints although he might have been working on two which were exhibited at the British Artists in 1824. The commission and Martin's execution of it are remarkable in several ways. Not only was it an extensive undertaking for

the publisher, involving four separate editions of parts and then bound volumes, but Martin, using for him a new medium, designed and engraved the 48 illustrations directly on the plates, with only the briefest of oil sketches (R.T. Laughton and private collections) for preliminary studies.

Prowett first commissioned Martin to do 24 mezzotint illustrations for which he was paid £2000; but soon afterwards, and before these were completed, he commissioned a further 24 on smaller plates for £1500. From the two sets of engravings, Prowett proceeded to issue four separate editions of parts; two illustrations to each part, with forty-eight pages of text printed on J. Whatman Turkey Mill paper, in twelve monthly installments, the first appearing on March 20th, 1825. Not surprisingly, in such a complicated undertaking, there were a few delays, as the last parts with title and dedication pages to the whole did not appear until 1827.

These were the four editions:

1. Imperial (or Elephant) Folio, 55.3 x 38.3, with proofs of the larger set of engravings, limited to 50 copies, at 24 guineas.
2. Imperial Quarto, 38.8 x 27.7, with prints from the larger plates, at £10.16s.
3. Imperial Quarto, with proofs from the small set of engravings, limited to 50 copies, at 12 guineas.
4. Imperial Octavo, 27.7 x 18.9. with prints from the smaller plates, at 6 guineas.

The average sizes of the plates are 35.6 x 25.4 and 26.8 and 19.8.

As well as these editions, proofs and prints were issued without letterpress and the remaining parts were bound and published complete in 1827. The text of all the editions was printed in the same type which was reset for each page size.

Complete sets of the parts of all editions are very rare. Only three copies of the Elephant Folio are known, one of which belonged to King George IV, who subscribed to all four editions, and to whom the work is dedicated. (Royal Library, Windsor)

A complete set of the parts to the Imperial Quarto (unlimited) edition, all in their original wrappers, is in the possession of Christopher Drake. The following description of the set conveys some idea of the history of the entire printing.

Each part is bound in a light grey-blue paper wrapper.

Front of wrapper of first part:

Part 1 Price 18s. 0d.

<div style="text-align:center">

DEDICATED BY PERMISSION

TO

THE KING

PARADISE LOST

BY

JOHN MILTON

ILLUSTRATED BY

JOHN MARTIN, ESQ

LONDON:

SEPTIMUS PROWETT, 23 OLD BOND STREET

1825

</div>

Back of wrapper of first part:

<div style="text-align:center">

PLATES IN PART THE FIRST

THE FALL OF THE ANGELS

PANDEMONIUM

PRINTED BY THOMAS WHITE 2 JOHNSON'S COURT:

With type cast at the foundry of Austin and Son

</div>

The plates are lettered:

Designed and Engraved by J. Martin Esqr.
Book 1, Line 44

London Published by Septimus Prowett, 23 Old Bond Street, 1825

The plate to Book 1, Line 44 is not inscribed. *Pandemonium (*Bk. 1, 710) is inscribed 'J. Martin 1824'.
The part contained the text of Book 1 and Book 2 to line 302.

Part II
Book 1, Line 314 (inscribed 'J. Martin 1824') *SATAN AROUSING THE FALLEN ANGELS*
Book 7, Line 339 (inscribed 'J. Martin 1824') *CREATION OF LIGHT*

With the added lettering on both plates 'Printed by Chatfield and Coleman'
To the back wrapper is added:
'The plates printed by Chatfield and Coleman Cannon Street'
Text: Book 2, Line 303 to Book 3, The Argument.

Part III
Book 2, Line 1 (inscribed 'J. Martin 1824') *SATAN PRESIDING AT THE INFERNAL COUNCIL*
Book 2, Line 727 (inscribed 'J. Martin 1825') *THE CONFLICT BETWEEN SATAN AND DEATH*
Text: Book 3 to Book 4, Line 406.

Part IV
Book 1, Line 192 *SATAN ON THE BURNING LAKE*
Book 11, Line 78 *HEAVEN - THE RIVERS OF BLISS*
plates now lettered 'Printed by Chatfield & Co'
Text: Book 4, Line 407 to Book 5, Line 146.

Part V
Book 4, Line 502 *SATAN CONTEMPLATING ADAM AND EVE IN PARADISE*
Book 4, Line 813 *EVE'S DREAM - SATAN AROUSED*
Text: Book 5, Line 147 to Book 6, The Argument

Part VI
Book 3, Line 365 *THE COURTS OF GOD*
Book 3, Line 501 *SATAN VIEWING THE ASCENT TO HEAVEN*
Text: Book 6.

Part VII

Dated 1826 on front wrapper

Book 5, Line 308 *PARADISE - WITH THE APPROACH OF THE ARCHANGEL RAPHAEL*

Book 5, Line 136 *PARADISE - ADAM AND EVE - THE MORNING HYMN*

Plates no longer lettered '1825' after Prowett's address, and are now 'Printed by Lahee.'

Back wrapper adds line 'The plates Printed by J. Lahee Castle Street Oxford Street'.

Text: Book 7 complete.

The last page is lettered 'End of Vol. 1', followed by the printer's device, the motto 'Te Favente Virebo' above a woman watering flowers and 'Thomas White Johnson's Court, Fleet Street.'

Part VIII Front wrapper now reads 'London: Septimus Prowett, 1826'.

Book 4, Line 866 *THE ANGELS GUARDING PARADISE AT NIGHT*

Book 4, Line 453 *EVE AT THE FOUNTAIN*

Plates lettered '1826' after Prowett's address and 'Printed by James Lahee'.

Back wrapper drops type founder's line.

Text: Book 8 to Book 9, Line 42

Part IX

Book 5, Line 519 *RAPHAEL CONVERSING WITH ADAM AND EVE*

Book 9, Line 780 *SATAN TEMPTING EVE*

Plates lettered 'Printed by Chatfield & Co'.

Text: Book 9, Line 43 to Line 874.

Part X

Book 10, Line 108 *ADAM HEARING THE VOICE OF THE ALMIGHTY*

Book 10, Line 863 *ADAM REPROVING EVE*

Plates lettered 'London Published by Septmius Prowett, 62 Paternoster Row, 1826' and 'Printed by J. Lahee'.

Text: Book 9, Line 875 to Book 10, Line 406.

Part XI

Book 10, Lines 312, 347 *BRIDGE OVER CHAOS*

Book 11, Line 226 *APPROACH OF THE ARCHANGEL MICHAEL*

Plates 'Printed by Chatfield & Co.'

Text: Book 10, Line 407 to Book 11, Line 458.

Part XII

Book 9, Line 996 *EVE PRESENTING THE FORBIDDEN FRUIT TO ADAM*

Inscribed 'J. Martin 1824'.

Book 12, Line 641 *ADAM AND EVE DRIVEN OUT OF PARADISE*

Plates dated '1827 after publisher's address and 'Printed by J. Lahee'

Text: Book 11, Line 459 to the end.

Last page of text lettered 'The End' with printers device and address is on last page of Part VII.

Followed by 5 unnumbered pages.

A)

MILTON'S
PARADISE LOST
VOL. I

B)

MILTON'S
PARADISE LOST
VOL. I

C)

THE
PARADISE LOST
OF
MILTON
WITH ILLUSTRATIONS DESIGNED AND ENGRAVED
BY
JOHN MARTIN
VOL. I
LONDON
SEPTIMUS PROWETT
M.DCCC.XXVII

(Printer's address on reverse)

D) Same as above with 'VOL. II'

TO
HIS MOST GRACIOUS MAJESTY
GEORGE THE FOURTH
SOVEREIGN OF THE BRITISH EMPIRE
THIS
ILLUSTRATED EDITION
OF
PARADISE LOST
IS, WITH PERMISSION
DEDICATED TO HIS MAJESTY'S
LOYAL AND GRATEFUL SUBJECT
SEPTIMUS PROWETT

FEBRUARY 28, 1827.

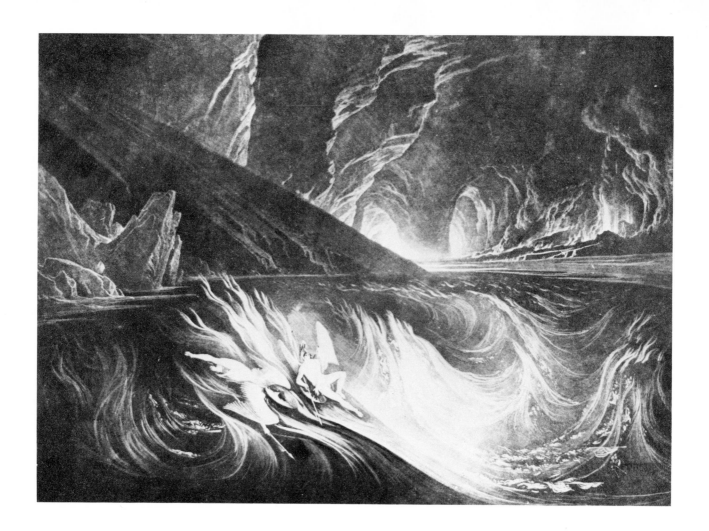

1. Book 1, Line 192 *Satan on the burning lake*
Thus Satan talking to his nearest mate
With Head uplift above the wave, and eyes
That sparkling blazed; his otherparts besides
Prone on the flood, extended long and large
Lay floating many a rod, in bulk as huge
As whom the fables name of monstrous size . . .

2. Book 1, Line 314 *Satan arousing the fallen angels*
(313) He called so loud that all the hollow deep
Of Hell resounded: 'Princes, Potentates,
Warriors, the flow'r of heav'n, once yours, now lost,
If such astonishment as this can seize
Eternal Spirits; or have ye chos'n this place
After the toil of battle to repose
Your wearied virtue, for the ease you find
To slumber here, as in the vales of Heav'n?
Or in this abject posture have ye sworn
To adore the Conqueror . . . '

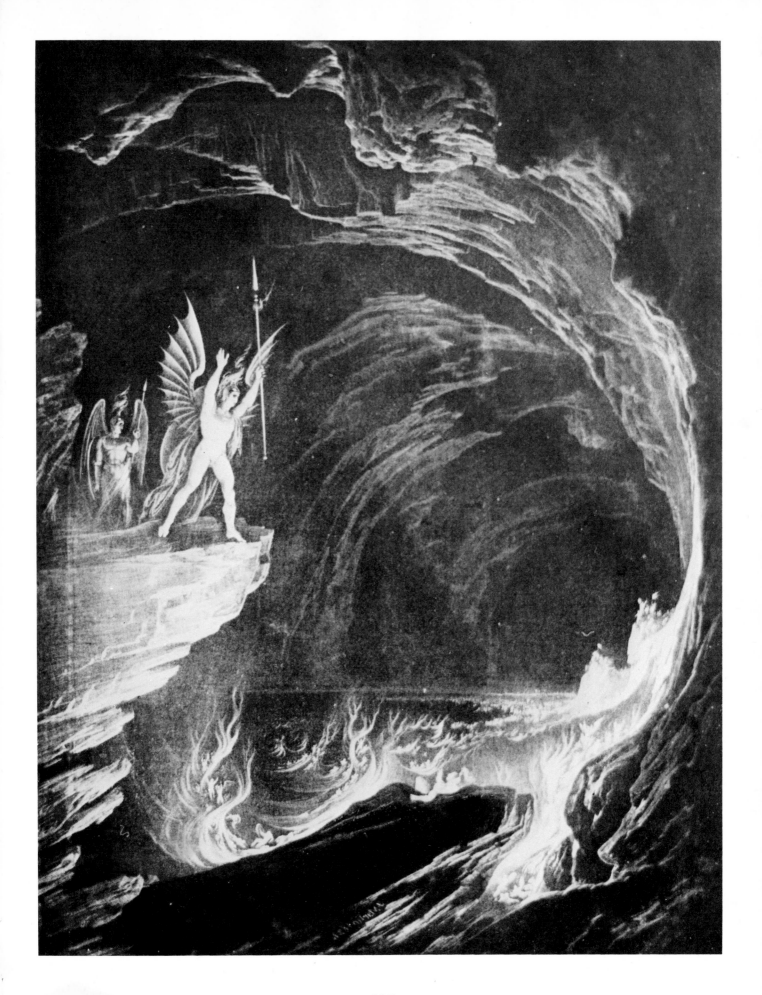

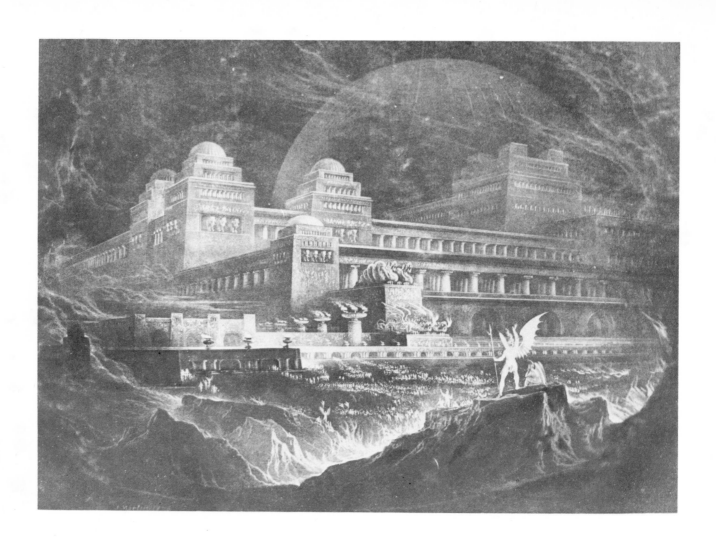

3. Book 1, Line 710 *Pandemonium*
Anon out of the earth a fabric huge
Rose like an exhaltation, with the sound
Of Dulcet symphonies and voices sweet,
Built like a temple, where pilasters round
Were set, and Doric pillars overlaid
With golden architrave; nor did there want
Cornice or frieze, with bossy sculptures grav'n;
The roof was fretted Gold . . .

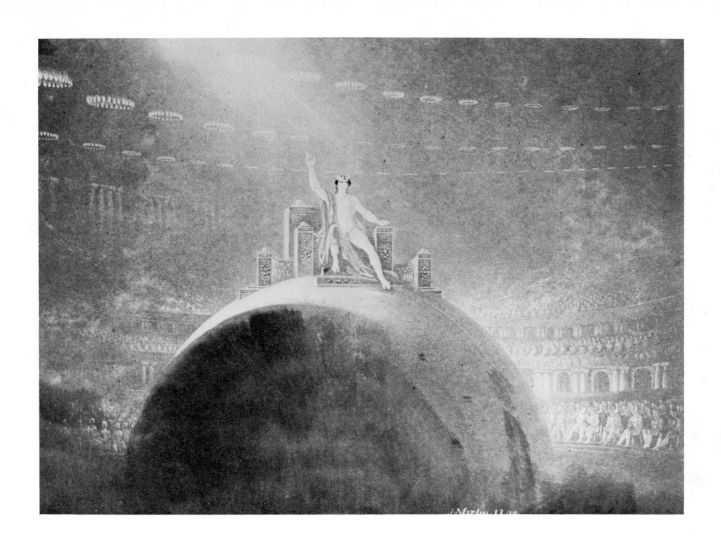

4. Book 2, Line 1 *Satan presiding at the infernal council* (small plate)
High on a throne of royal state, which far
Outshone the wealth of Ormus and Ind,
Or where the gorgeous East with richest hand
Show'rs on her kings barbaric pearl and gold,
Satan exalted sat, by merit raised
To that bad eminence; and from despair
Thus high uplifted beyond hope, aspires
Beyond thus high, insatiate to pursue
Vain war with Heav'n, and by success untaught,
His proud imaginations thus displayed . . .

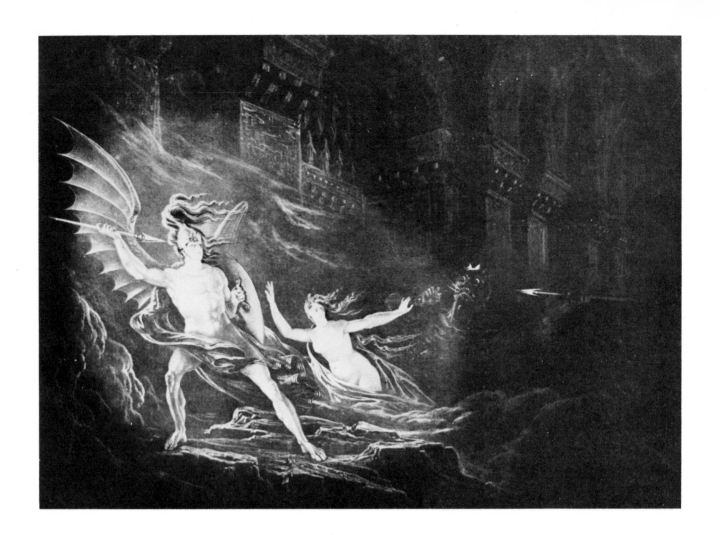

5. Book 2, Line 727 *The conflict between Satan and Death*
'O father, what intends thy hand,' she cried,
'Against thy only son ? What fury, O son,
Possesses thee to bend that mortal dart
Against thy father's head? And know'st for whom?
For him who sits above and laughs the while
At thee ordained his drudge, to execute
Whate'er his wrath, which he calls justice bids,
His wrath, which one day will destroy ye both.'

6. Book 3, Line 501 *Satan viewing the ascent to Heaven*
. . . far distant he descries
Ascending by degrees magnificent
Up to the wall of heaven a structure high,
At top whereof, but far more rich appeared
The work of a kingly palace gate
With frontispiece of diamond and gold
Embellished . . .

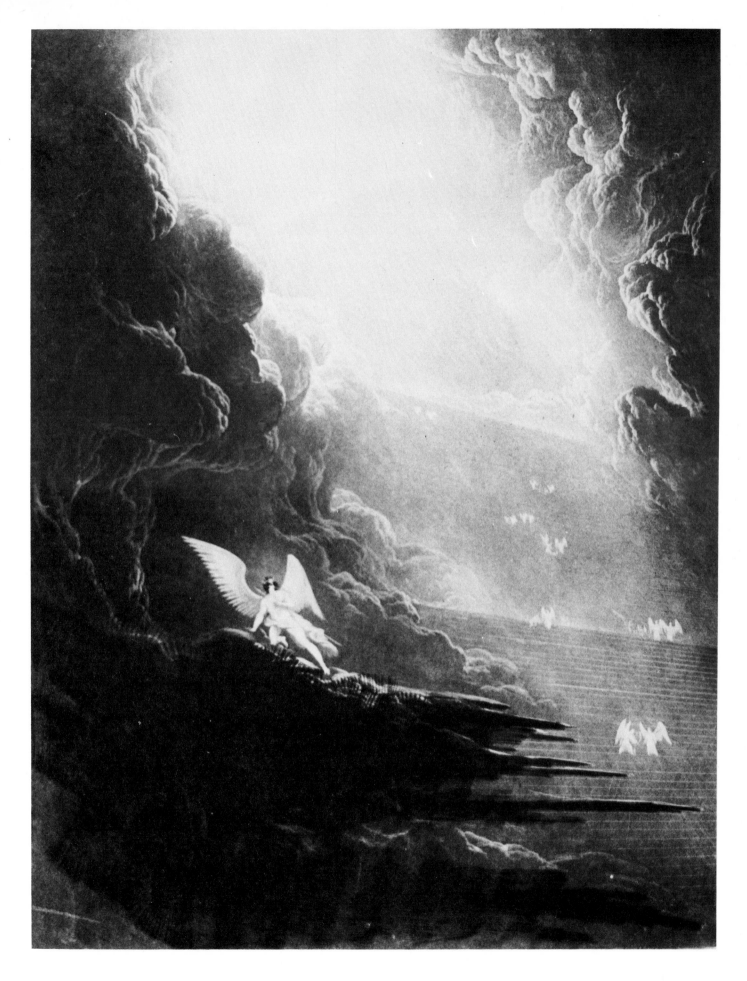

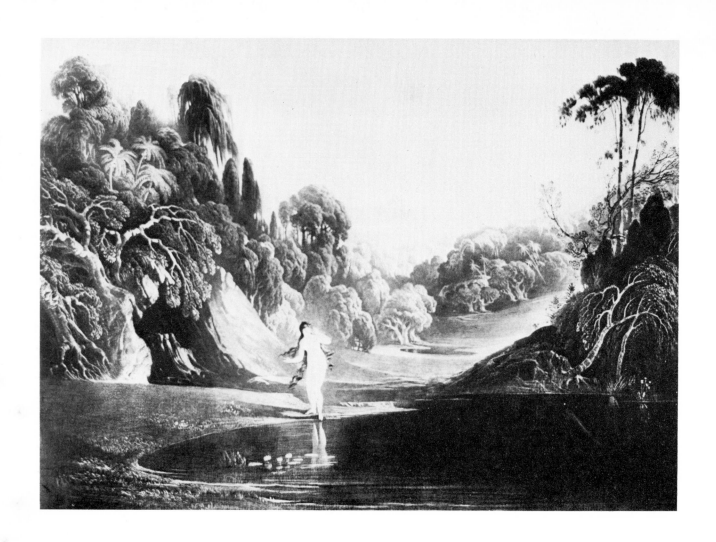

7. Book 4, Line 453 *Eve at the fountain*
Not distant far from thence a murmuring sound
Of waters issued from a cave and spread
Into a liquid plain, then stood unmoved
Pure as th' expanse of heav'n; I thither went
With unexperienced thought, and laid me down
On the green bank, to look into the clear
Smooth lake, that to me seemed another sky.
As I bent down to look, just opposite
A shape within the wat'ry gleam appeared
Bending to look on me

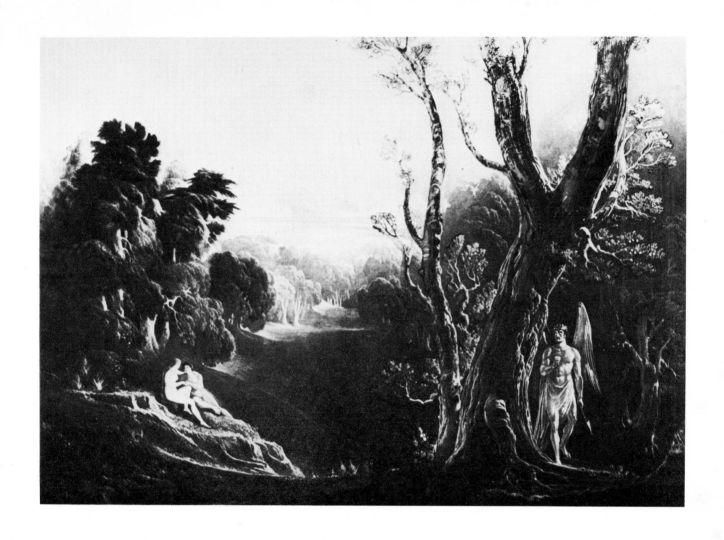

8. Book 4, Line 502 *Satan contemplating Adam and Eve in Paradise*
 . . . Aside the Devil turned
For envy, yet with jealous leer malign
Eyed them askance, and to himself thus plained:
 'Sight hateful, sight tormenting! thus these two
Imparadised in one another's arms,
The happier Eden, shall enjoy their fill
Of bliss on bliss, while to hell am thrust.'

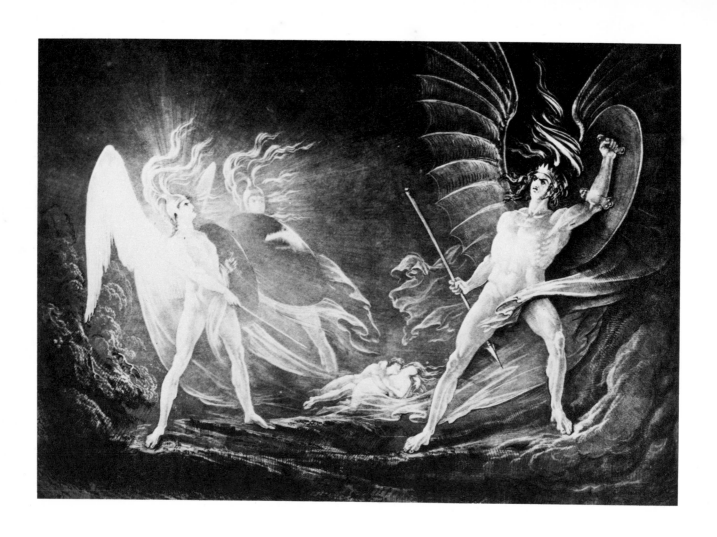

9.　　Book 4, Line 813 *Eve's dream - Satan aroused*
. . . up he starts
Discovered and surprised. As when a spark
Lights on a heap of nitrous powder, laid
Fit for the tun some magazine to store
Against a rumored war the smutty grain
With sudden blaze diffused, inflames the air:
So started up in his own flame the Fiend.
Back stepped those two fair angels half amazed
So sudden to behold the grisly king . . .

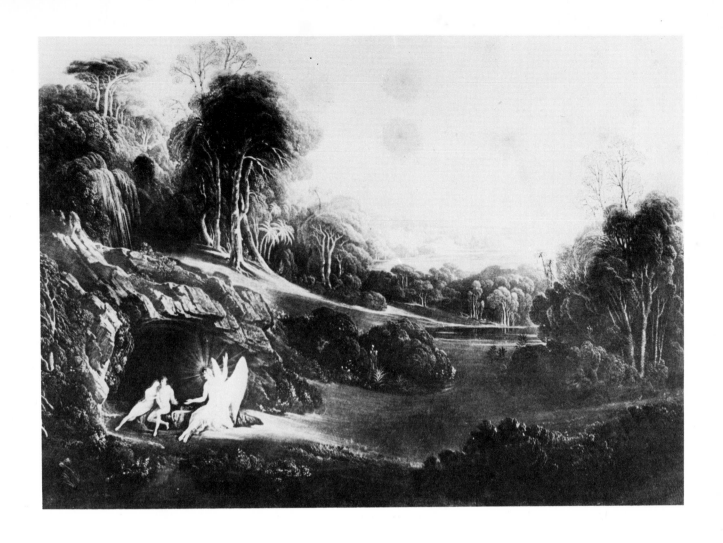

10. Book 5, Line 519 *Raphael conversing with Adam and Eve*
To whom the Angel: 'Son of heav'n and earth,
Attend: that thou art happy, owe to God;
That thou continu'st such, owe to thyself,
That is, to thy obedience; therein stand.
This was that caution giv'n thee; be advised.'

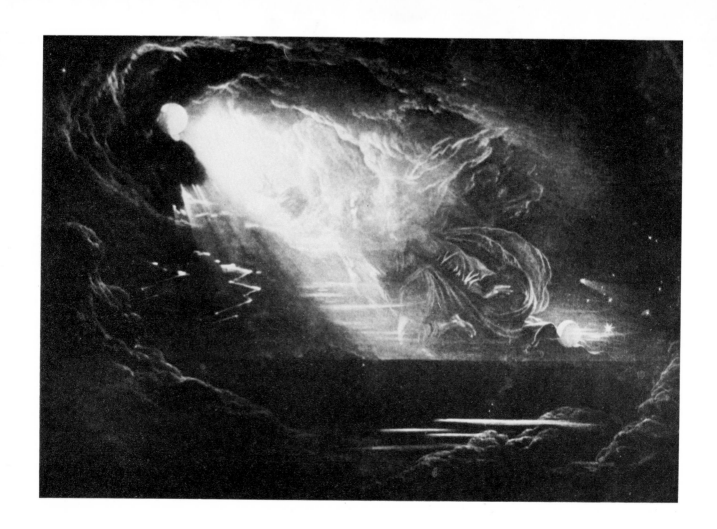

11. Book 7, Line 339 *Creation of Light*
Again the Almighty spake: 'Let there be lights
High in the expanse of heaven to divide
The day from night; and let them be for signs,
For seasons, and for days, and circling years,
And let them be for lights as I ordain
Their office in the firmament of heav'n
To give light on the earth'; and it was so.

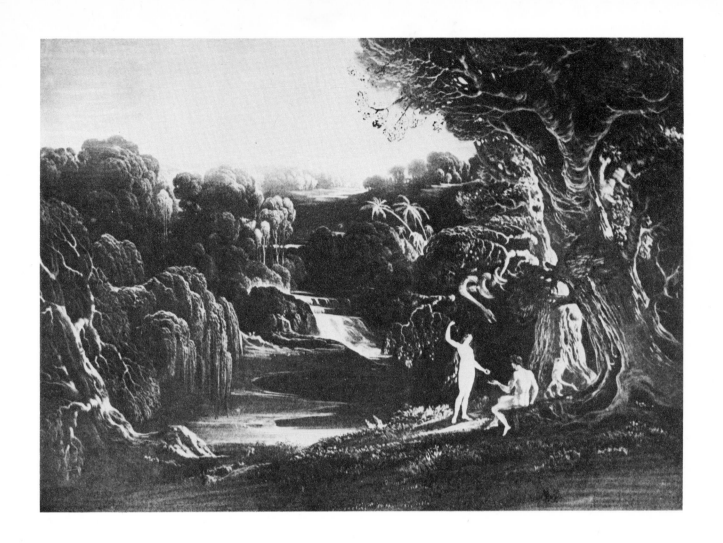

12. Book 9, Line 995 *Eve presenting the forbidden fruit to Adam* (small plate)
. . . from the bough
She gave him of that fair enticing fruit
With liberal hand. He scrupled not to eat
Against his better knowledge, not deceived,
But fondly overcome with female charm.

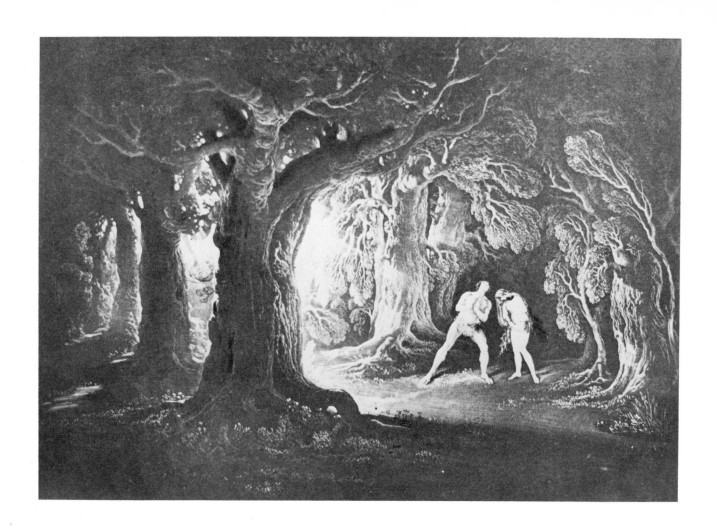

13. Book 10, Line 108 *Adam hearing the voice of the Almighty*
He came, and with him Eve, more loth, though first
To offend, discount'nanced both, and discomposed;
Love was not in their looks, either to God
or to each other, but apparent guilt,
And shame, and perturbation, and despair,
Anger, and obstinancy, and hate, and guile.

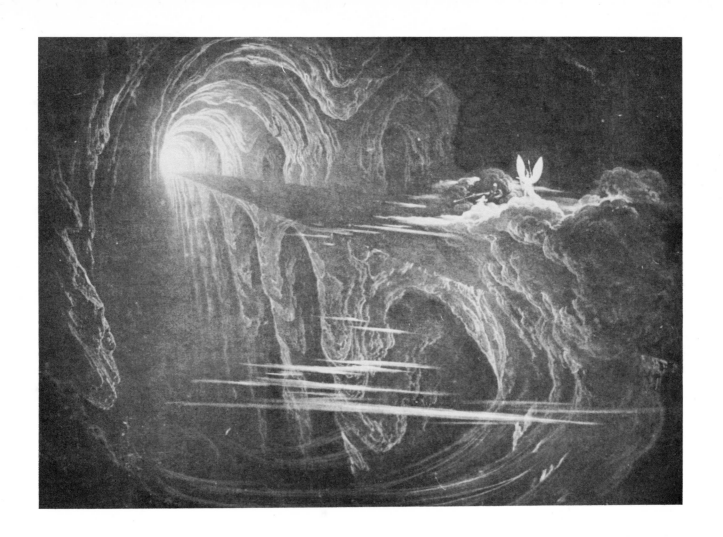

14. Book 10, Lines 312 and 347 *The Bridge of Chaos*
Now had they brought the work by wondrous art
Pontifical, a ridge of pendent rock
Over the vexed abyss, following the track
Of Satan, to the selfsame place where he
First lighted from his wrong, and landed safe
From out of Chaos to the outside bare
Of this round world
And at the brink of Chaos, near the foot
Of this new wondrous pontifice, unhoped
Met who to meet him came, his offspring dear.
Great joy was at their meeting, and at sight
Of that stupendious bridge his joy increased.

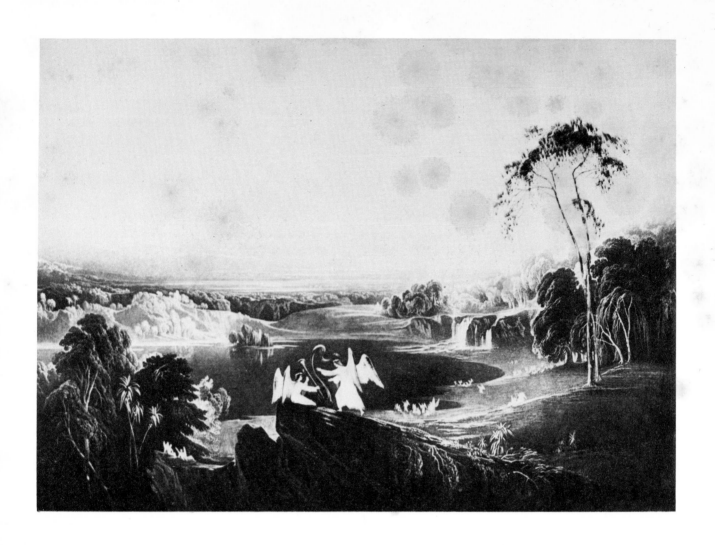

15. Book 11, line 78 *Heaven - the rivers of bliss*
Of amarantine shade, fountain or spring,
By the waters of life, where'er they sat
In fellowship of joy, the sons of light
Hasted, resorting to the summons high,
And took their seats.

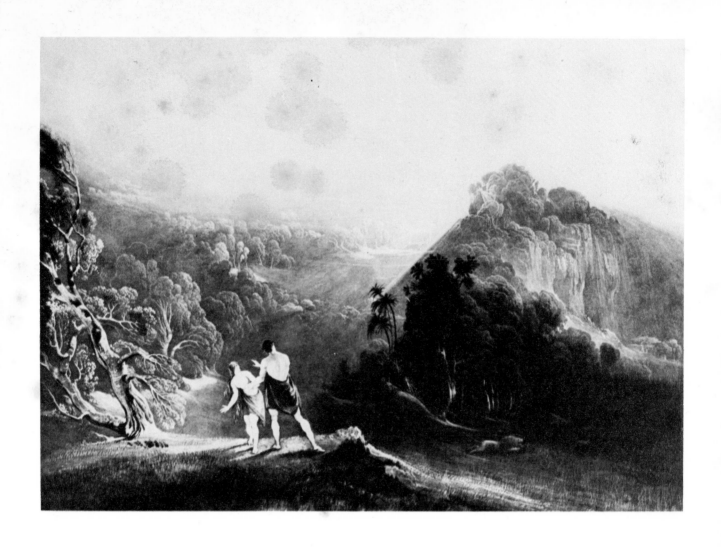

16. Book 11, Line 226 *The approach of the Archangel Michael*
'Eve, now expect great tidings, which perhaps
Of us will soon determine, or impose
New laws to be observed; for I descry
From yonder blazing cloud that veils the hill
One of the heav'nly host, and by his gait
None of the meanest, some great Potentate
Or of the Thrones above, such majesty
Invests him coming . . .

SELECT BIBLIOGRAPHY

Books

John Martin, Painter Mary L. Pendred, London, 1923
> Contains quotations from the diaries of Serjeant Ralph Thomas, a close friend of Martin's. The diaries have since been lost.

John Martin 1789-1854, His Life and Works Thomas Balston, London, 1947
> Gives detailed bibliography of early sources. See especially the author's annotated and interleaved copies in the Victoria and Albert Museum Library.

Tracks in the Snow Ruthven Todd, London, 1946

John Martin en France Jean Seznec, London, 1964

Art and the Industrial Revolution Francis Klingender, edited and revised by Arthur Elton, London, 1968

Milton and English Art Marcia Pointon, Manchester, 1970

Exhibition Catalogues

(A complete list of Martin's own exhibitions and pamphlets is given in Balston).

Tyneside's Contribution to Art, Festival of Britain Exhibition: John Martin Introduction by Thomas Balston, Laing Art Gallery, Newcastle, 1951

John Martin 1789-1854 Foreword by Thomas Balston; 'The Art of John Martin' by Eric Newton, Whitechapel Art Gallery, London, 1953

John Martin 1789-1854: Artist-Reformer-Engineer Introduction by William Feaver, Laing Art Gallery Newcastle, 1970.

The Bristol School of Artists: Francis Danby and Painting in Bristol 1910-1840 Catalogue by Francis Greenacre, City Art Gallery, Bristol, 1973

Periodicals

'John Martin and Metropolitan Improvements'; Thomas Balston, *Architectural Review* Vol CII, No. 612, December, 1947

'The Architectural Backgrounds in the Pictures of John Martin'; Norah Monckton, *Architectural Review* Vol. CIV, No. 620, August, 1948

'John Martin: New Discoveries'; Thomas Balston, *Burlington Magazine* Vol. XCIII, No. 582, September, 1951

'Two paintings by John Martin'; Richard James, *Burlington Magazine* Vol. XCIV, No. 593, August, 1952

'*Le Feu du Ciel* de Victor Hugo et John Martin'; Christopher Thompson, *Gazette des Beaux-Arts* Vol. LXV, April, 1965

132